IMAGES
of America

CONNECTICUT IN WORLD WAR II

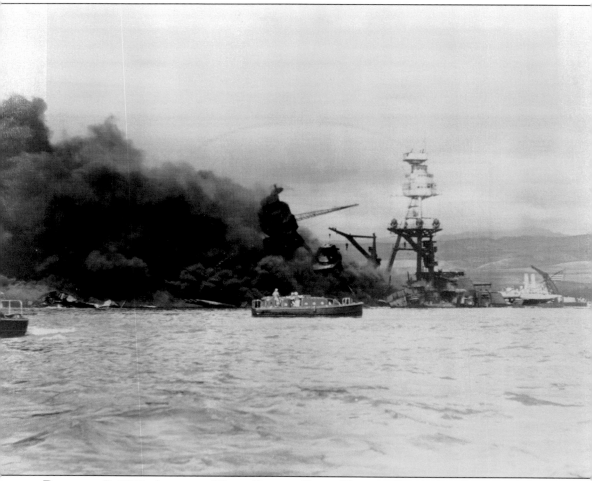

DECEMBER 7, 1941, AMERICAN NAVAL BASE AT PEARL HARBOR. Hundreds of Japanese fighter planes attacked the American naval base at Pearl Harbor near Honolulu, Hawaii, just before 8:00 a.m. on December 7, 1941. And with it, life in America would change forever. The devastating barrage lasted just two hours but managed to destroy nearly 20 American naval vessels, including the USS *Arizona*, pictured here, and more than 300 airplanes. (Courtesy of the Library of Congress, LC-USZ62-104778.)

ON THE COVER: From propellers produced by Hamilton Standard to engines invented by Pratt & Whitney, Connecticut ingenuity was on display throughout World War II. Pictured here are factory workers from another pivotal manufacturer, the Vought-Sikorsky Aircraft Corporation. In 1939, United Aircraft moved Vought to Stratford, where its Sikorsky division was located, and renamed the merged divisions Vought-Sikorsky Aircraft. (Courtesy of the Library of Congress, LC-DIG-fsa-8a34623.)

IMAGES
of America

CONNECTICUT IN WORLD WAR II

Mark Allen Baker

ARCADIA
PUBLISHING

Copyright © 2017 by Mark Allen Baker
ISBN 978-1-4671-2698-4

Published by Arcadia Publishing
Charleston, South Carolina

Printed in the United States of America

Library of Congress Control Number: 2017939252

For all general information, please contact Arcadia Publishing:
Telephone 843-853-2070
Fax 843-853-0044
E-mail sales@arcadiapublishing.com
For customer service and orders:
Toll-Free 1-888-313-2665

Visit us on the Internet at www.arcadiapublishing.com

To Ann and Mark Lepkowski, thank you for your enduring friendship.

CONTENTS

ACKNOWLEDGMENTS

To Erin L. Vosgien, Arcadia Publishing acquisitions editor, and Henry Clougherty, Arcadia Publishing title manager, I am grateful for this opportunity.

I wish to extend my gratitude to the following Connecticut institutions: Hartford Circus Fire Memorial committee members, New England Air Museum, Connecticut Historical Society (Hartford), and the *Hartford Courant*. I would also like to acknowledge Marilyn Allen Baker and the family of Dennis DiGiovanni for their contributions.

Books, like the one in your hand, are possible because of the Library of Congress and its wonderful staff, who assisted me specifically on the material found in Farm Security Administration/Office of War Information collection and the Historic American Engineering Record. You are encouraged to visit the archive for a rare view of life during World War II. Every effort has been made to conform to the rights and restrictions on every image that appears in this publication. In the event of a discrepancy due to mislabeling, please contact us immediately. Although the people, places, and things of the period are firmly etched into our mindset, the ambiguous nature of public domain makes it necessary for us to promulgate the disclaimer: All registered trademarks that appear inside this publication are the property of their respective corporations. Also a word of acknowledgement to the National Archives, Smithsonian Institution, US Census Bureau, US Office of Emergency Management, US Mint, US Postal Service, and US Department of War.

All this being said, we are not a perfect society. Poorly documented during this period were the struggles by minorities and their achievements. Thankfully, some have come into the spotlight, such as the Tuskegee Airmen—the first African American military aviators in the US armed forces—but more needs to be done. Also casting a variegated cloud over the period was the silhouette of an enemy we did not understand and, thus, shameful actions such as Executive Order 9066. This act, signed by Pres. Franklin Roosevelt on February 19, 1942, forced the internment of over 100,000 residents of Japanese ancestry, 77,000 of whom were American citizens.

Unless otherwise noted, all images appear courtesy of the Library of Congress and an insert reference number often beginning with LC, DIG, US, or a control number may appear in parentheses following some captions. In nearly every situation, a digital file from the original negative was used.

To my friends and family, especially my wife, Alison, I appreciate your love and support.

INTRODUCTION

Since the beginning of our American history we have been engaged in change, in a perpetual, peaceful revolution, a revolution which goes on steadily, quietly, adjusting itself to changing conditions without the concentration camp or the quicklime in the ditch. The world order which we seek is the cooperation of free countries, working together in a friendly, civilized society. This nation has placed its destiny in the hands and heads and hearts of its millions of free men and women, and its faith in freedom under the guidance of God. Freedom means the supremacy of human rights everywhere. Our support goes to those who struggle to gain those rights and keep them. Our strength is our unity of purpose. To that high concept there can be no end save victory.

—Franklin D. Roosevelt, Annual Message to Congress, January 6, 1941

These words rang out across the state of Connecticut, from the counties of Litchfield, Hartford, Tolland, and Windham to Fairfield, New Haven, Middlesex, and New London. From the dreams of our forefathers, many who forged this great nation from the very soil beneath our feet, we gathered strength before polishing it in unity.

Americans live in a world founded on four essential freedoms, as President Roosevelt so eloquently expounded in his message to Congress: "The first was freedom of speech and expression— everywhere in the world; the second the freedom of every person to worship God in his own way—everywhere in the world; the third a freedom from want—which, translated into world terms, means economic understandings which will secure to every nation a healthy peacetime life for its inhabitants—everywhere in the world; and finally, the freedom from fear—which, translated into world terms, means a world-wide reduction of armaments to such a point and in such a thorough fashion that no nation will be in a position to commit an act of physical aggression against any neighbor anywhere in the world." It was these remarks that resonated in the hearts of a nation and the souls of our state.

And although Americans could hear the words, they could not see them. That required an artist's rendition. Seventy-two miles northwest of Hartford, Connecticut, Norman Perceval Rockwell, an illustrator for a popular publication, the *Saturday Evening Post*, put brush to canvas in his Stockbridge, Massachusetts, studio and painted our reflection. The empathetic images, which were first published on February 20, February 27, March 6, and March 13, 1943, along with commissioned essays from leading American writers and historians (Booth Tarkington, Will Durant, Carlos Bulosan, and Stephen Vincent Benét), featured models—many Rockwell's neighbors—that struck a patriotic chord. The series became so popular following publication that the magazine received millions of reprint requests. The images were pinned to every bedroom wall in Bloomfield and every garage in Glastonbury, or so it appeared.

And it was these four indispensable rights that resonated from the people, places, and things associated with Connecticut in World War II.

Pres. Warren Harding died in office on August 2, 1923, and was succeeded by his Republican vice president, Calvin Coolidge (1923–1929). Herbert Hoover, also a Republican, took over on March 4, 1929, and served a single term before handing Democrat Franklin Roosevelt (1933–1945) a country at the nadir of the worst depression in its history. And, as if that alone were not enough, along came the attack on Pearl Harbor and World War II. Vice Pres. Harry S. Truman (1945–1953) succeeded to the office of the president of the United States following Roosevelt's death on April 12, 1945.

Connecticut, having turned to the governorship of Wilbur Lucius Cross (1931–1939), then looked to Raymond E. Baldwin (1939–1941, 1943–1946) and Robert A. Hurley (1941–1943) to lead us up to and through World War II. Later, they would be followed by Charles W. Snow (1946–1947), James L. McConaughy (1947–1948), James C. Shannon (1948–1949), and Chester Bowles (1949–1951), who would take us into the Fabulous Fifties.

As war was dawning across Europe, Connecticut, like so many other states, pondered the alternatives. The Great Depression had taken a toll on our nation, but honestly speaking, the growing pro-war sentiment was bringing jobs to Connecticut. Everything changed on December 7, 1941, when the attack on Pearl Harbor resulted in the declaration of war. Our nation's position clear, an invigorated Connecticut went to work.

By 1945, over $8 billion in war contracts had found their way to Hamilton Propellers, Electric Boat, Pratt & Whitney, and other Connecticut companies. It came at a cost, however, as the influx of labor taxed state resources. Transportation, along with housing, was at a premium and created conflict among residents. All this as the state was portrayed in the media, specifically in films such as *Holiday Inn* (1942), *Christmas in Connecticut* (1945), and *Mr. Blandings Builds His Dream Home* (1948), as snow-covered rolling hills filled with quaint little villages where residents drove horse-driven sleighs to the local Grange hall on the town green. While there were occasions in Milford, Greenwich, and Litchfield when a visitor would not have been surprised to see Marjorie Reynolds, flanked by Bing Crosby and Fred Astaire, strolling the sidewalks, Connecticut residents knew better. For all intents and purposes, when citizens were not working or thinking about work, they were engaged in preparing for it. Sleep was always at a premium.

The demand for Connecticut males needed for fighting led to a workforce transformation across the state. With few options, townsfolk turned to their neighbors, many of them female. There has never been a time in our illustrious history when we asked so much of women. Not only did they meet every single expectation, they exceeded it. There were 350,000 women wearing the uniform while an estimated 6.5 million were at work on the home front. They raised families, built engines, stitched parachutes, and welded propellers with a degree of proficiency never seen. Women across Connecticut suspended their concerns for their loved ones, be they sons, daughters, or husbands, to focus on the task at hand. Their ability to compartmentalize was simply extraordinary.

One

A RENDEZVOUS WITH DESTINY

Tom Brokaw has used the term "The Greatest Generation," and Pres. Franklin D. Roosevelt quipped, "This generation of Americans has a rendezvous with destiny." Having been compared to people involved in the revolution of 1776 and even the Civil War, that generation's significance in shaping the nation was indeed profound. Never had citizens witnessed such an unparalleled national commitment to the only result that was acceptable—victory.

America had turned to its youth to carry the bulk of the burden. Many born after the conclusion of World War I engaged with tremendous pride. They may have left Connecticut as boys and girls, but those who returned were now men and women. Having witnessed firsthand the effects of the Great Depression, this generation had seen their parents' aspirations die as swiftly as the banks shut their doors. They were determined not to allow any aspect of the American dream to perish. A new president had promised a New Deal for the hard-pressed American people, declaring to the nation that "the only thing we have to fear is fear itself." Many bought into the proclamation and were determined to live their lives forever by that mantra.

When Japan formally surrendered on September 2, 1945, ending World War II, America knew the transition back to peacetime would not be easy, but it had to be simpler than battling the enemy. Fortunately, the general postwar expansion did not exclude Connecticut, thanks in part to highway construction. By 1950, the population of the state had increased to over two million, an annual rate of over 17 percent. Connecticut, thanks to Colt, Pratt & Whitney, Chance Vought, Hamilton Standard, Electric Boat, and General Electric, to name a few, had manufactured over four percent of the total US military armaments produced during World War II. This placed Connecticut ninth among the 48 states. There was no doubt in anyone's mind where Connecticut stood in regards to its love of country and commitment to freedom.

NEWSBOYS IN HARTFORD, CONNECTICUT, 1924. It would be the faces of this generation, born during World War I (1914–1918), that would endure the adversities of another world war. And if that were not enough, sandwich in the Great Depression. The world seemed a lot bigger then, incomprehensible to nearly all.

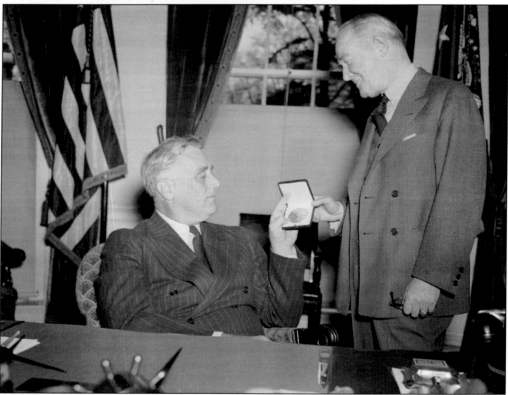

PRESIDENT ROOSEVELT AND GEORGE M. COHAN, 1940. The nation's rally call became a song penned in 1917 by George M. Cohan called "Over There." It galvanized young men to enlist in the Army, fight the "Hun," and return only when the conflict was over. Here, President Roosevelt acknowledges Cohan's Congressional Gold Medal for his two patriotic songs during World War I, "Over There" and "The Grand Old Flag."

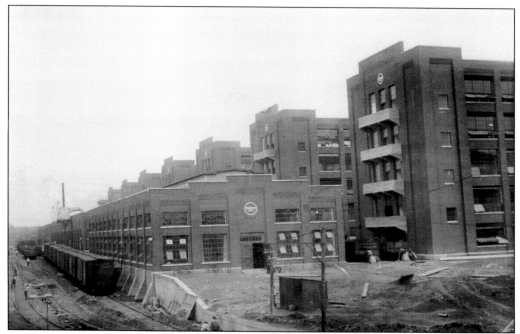

REMINGTON ARMS WORKS, BRIDGEPORT, CONNECTICUT, 1910. The military not only required quality frontline troops during World War I (it found an estimated 63,000 in Connecticut) but also superior supplies. When the United States entered the war effort, it was with the support of the finest workers available, and they were found inside the walls of Connecticut manufacturers. From Manchester silk and Waterbury brass to Bridgeport's Remington Arms, which produced 50 percent of the US Army's small arms cartridges, Connecticut stepped up.

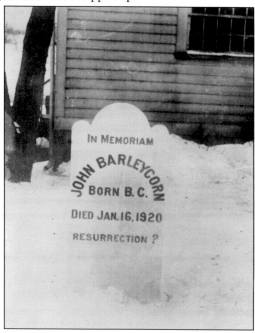

SILVER CITY MEN ERECT BARLEYCORN MONUMENT, 1920. Driven by temperance movements, churches, and state laws, Prohibition seemed inevitable by the beginning of the 20th century. Congress ratified the 18th Amendment on January 16, 1920, and nationwide Prohibition began on January 17, 1920. Worth noting, however, was that two states in the Union did not ratify the amendment: Rhode Island and Connecticut. Here, a tombstone dedicated to John Barleycorn notes his death as January 16, 1920, before being placed on the grounds of the 1711 Club in Meriden, Connecticut.

MERRITT PARKWAY CONSTRUCTION, TOLL GATE POND, C. 1939. Seeing Connecticut through the bulk of the Great Depression was a Yale graduate, Wilbur Cross. As governor, Cross did what he could to calm the state's labor unrest before riding the wave of Roosevelt's employment efforts. While Cross will likely be remembered most for his support of the Merritt Parkway, not to mention its continuation, it was his reactions to the 1936 flood and the 1938 hurricane that truly defined his leadership and allowed him to serve four terms as Connecticut's governor.

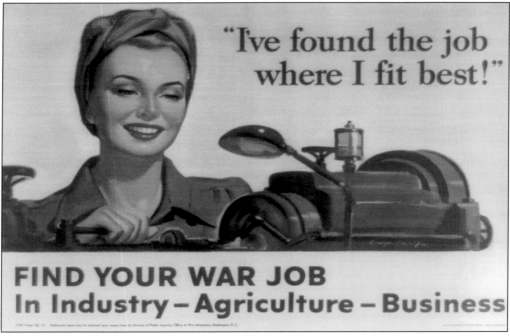

"I'VE FOUND THE JOB WHERE I FIT BEST!" In 1943, the demand for Connecticut men in fighting jobs led to the transformation of women in the workplace, not only in this state but across the Union. There has never been a time in the nation's history where so much was asked of women, and they exceeded every expectation.

Two

PEOPLE

The world is a dangerous place to live, not because of the people who are evil, but because of the people who don't do anything about it.

—Albert Einstein

Just the term *World War II* evokes a flood of memories. Naturally, it is often a personal recollection, associated with people, places, or things. So, this chapter will begin with those individuals with ties to Connecticut.

From well-known local and national leaders to aviators and sports figures, Connecticut had its fair share of prominent individuals in World War II. For some, the connection was clear, such as Gov. Raymond Baldwin, while for others it was less transparent. Take Sir Winston Leonard Spencer-Churchill for example. Churchill's great-great-grandfather Reuben Murray (1743–1810), according to the prime minister of the United Kingdom, served as a lieutenant in the Connecticut and New York regiments. Also, Churchill's great-grandmother, Aurora Murray, married Isaac Jerome, whose father, Aaron, was born in Wallingford, Connecticut, in 1764.

Individuals were also known only for the title of their job. People such as air raid wardens, shippers, and handlers played a vital role, even if they were not known on a first-name basis. For state residents unified in the cause of freedom, titles were a mere by-product.

Conflict also enabled people to overcome barriers. When Eleanor Roosevelt stated, "Pit race against race, religion against religion, prejudice against prejudice. Divide and conquer! We must not let that happen here," Connecticut residents heeded her advice.

The people pictured here are as diverse as those who served overseas in World War II, and for most Connecticut residents, just a glimpse of one, if not two, of these characters should spark a memory. In the unlikely event that it does not, then there are always places and things.

AIR RAID WARDENS, 1942. Some of Southington's 250 air raid wardens attend one of the weekly meetings in 1942. Each warden received a course in first aid, attended lectures and drills on material from *Methods of Combating Incendiary Bombs and Protection Against Gas*, and learned how to make out reports according to the US Office of Civilian Defense *Handbook for Air Raid Wardens*. Also, each warden was equipped with an arm band or suitable uniform; steel helmet, gas mask, and gas protective clothing (when available); a warden's whistle, and heavy work gloves. It was each warden's responsibility to see that everything possible was done to protect citizens and safeguard homes from the new hazards created by attack from the air or by enemies from within.

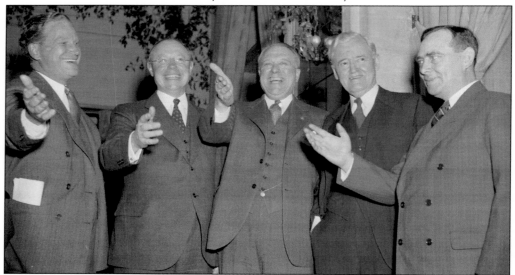

RAYMOND E. BALDWIN, 1939. Republican Raymond E. Baldwin (1893–1986) was a conservative who was elected governor of Connecticut in 1938 during a party landslide. His landmark cost cutting, however, may have cost the governor his 1940 reelection. Elected governor again in 1942 and 1944, Baldwin focused on the home front during the war. Later, he turned his attention toward the reallocation of Connecticut's peacetime resources. From left to right are Republican National Committee chairman John Hamilton, Sen. Robert Taft of Ohio, Baldwin, Sen. Clyde M. Reed of Kansas, and Rep. Joseph W. Martin Jr., House minority leader.

GEORGE H.W. BUSH, 1989. George Herbert Walker Bush, the 41st US president, was born on June 12, 1924, in Milton, Massachusetts, to Dorothy Walker Bush (1901–1992) and Prescott Bush (1895–1972), a banker who went on to represent Connecticut in the US Senate from 1952 to 1963. The younger Bush was raised in Greenwich, Connecticut, and graduated from Phillips Academy in Andover, Massachusetts, in 1942. After graduation, Bush joined the US Naval Reserve to fight in World War II. Receiving his wings shortly before his 19th birthday, Bush was the nation's youngest commissioned pilot at the time and flew 58 combat missions during the war. He received the Distinguished Flying Cross. His eldest son, George Walker Bush (the 43rd president), was born on July 6, 1946, in New Haven.

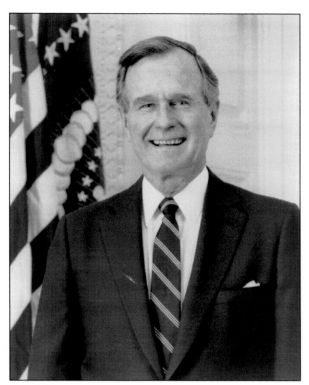

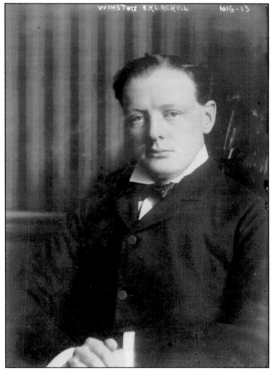

WINSTON LEONARD SPENCER-CHURCHILL, 1900. A British statesman and popular prime minister (1940–1945 and 1951–1955), Winston Churchill was a consistent opponent of appeasement during the 1930s. He replaced Neville Chamberlain as British prime minister in 1940 and led Britain throughout World War II. Churchill's notable literary works include *The Second World War* (1948–1953) and *A History of the English-Speaking Peoples* (1956–1958). He won the Nobel Prize for Literature in 1953.

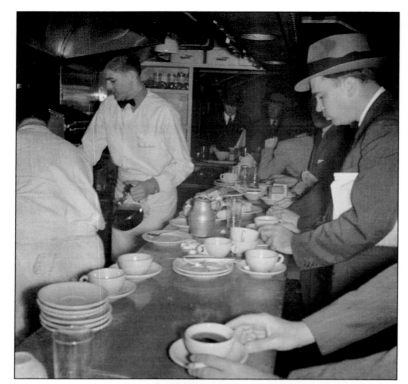

COMMUTERS, 1941. In 1941, Connecticut commuters to New York City played cards, chatted, snacked, used real silverware in the dining car, and typically read newspapers to pass the time while riding the train.

COMMUTERS PLAYING BRIDGE, 1941. Commuters play a friendly game of bridge while crossing bridges on the train to New York City. It was humorist Will Rogers who said, "Half our time is spent trying to find something to do with the time we have rushed through life trying to save." One cannot help but notice that ashtrays, at least on this train, must have been rationed as well.

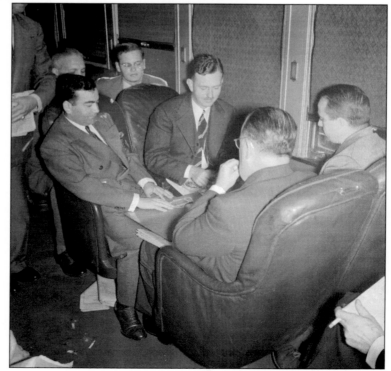

COMMUTERS SNACKING OR SMOKING, 1941. Grabbing a morning snack or a smoke while commuting into New York was a common occurrence on the train. Note the cigarette vending machine against the wall just over the table of seated men.

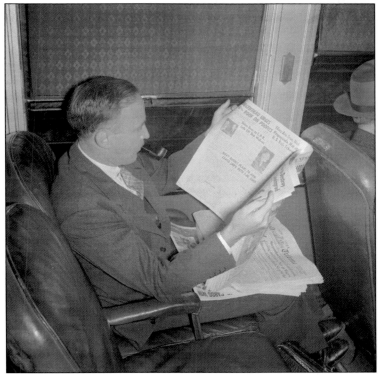

COMMUTERS READING, 1941. Pictured here is a Westport commuter reading the day's headlines during his train trip: "Morgenthau Urges 6% Roof On Profits," "Union Bows to F.D.R., Calls Off Ship Walkout," and "Navy Rushes Plans To Arm Cargo Ships With 5-In. Guns."

JOHN A. DANAHER, 1939. Born in Meriden, Connecticut, John Anthony Danaher was quick to distinguish himself in state politics. In 1938, he was elected to the US Senate as a Republican and served from January 3, 1939, until January 3, 1945. Following an unsuccessful reelection bid, he resumed his Hartford law practice before being appointed a circuit judge of the US Court of Appeals for the District of Columbia Circuit (1954–1969) by Pres. Dwight D. Eisenhower.

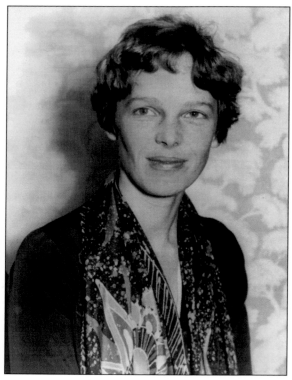

AMELIA M. EARHART, 1928. Aviation pioneer and author Amelia Mary Earhart discreetly married George Palmer Putnam in Noank, Connecticut, on February 7, 1931. As the first female aviator to fly solo across the Atlantic Ocean, Earhart received the Distinguished Flying Cross for the accomplishment. In 1937, she disappeared somewhere over the Pacific Ocean in a Lockheed Model 10 Electra. Ever since, intrigue regarding her life, career, and disappearance has haunted aviators.

DWIGHT D. EISENHOWER, 1952.
Holding titles such as 16th chief of staff of the Army (1945–1948), governor of the American zone of occupied Germany (1945), 13th president of Columbia University (1948–1953), and first supreme allied commander Europe (1951–1952), Dwight David Eisenhower was known to most of his friends simply as "Ike." On October 20, 1954, President Eisenhower gave remarks at the Trinity College Convocation in Hartford, confirming that war will never again exist as his generation knew it and victory will be measured only by "degrees of destruction."

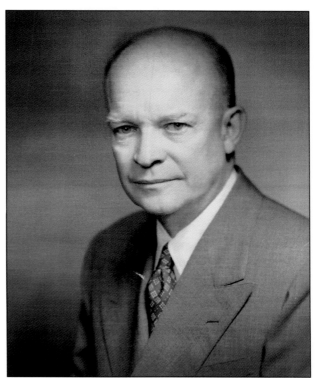

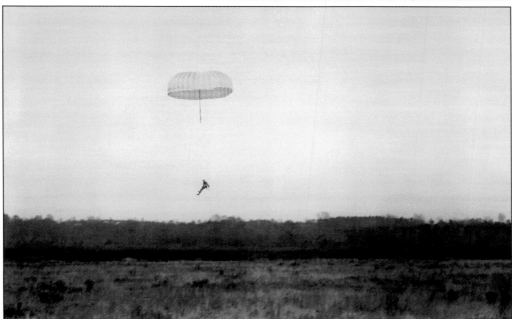

ADELINE GRAY/PARATROOPERS, 1942. The importance of proper folding and rigging of parachutes was well known to Adeline Gray. On June 6, 1942, Adeline Gray made the first jump by a human with a nylon parachute at Brainard Field in Hartford. Her jump, performed before a group of Army officials, put the canopy developed by the Pioneer Parachute Company to the test.

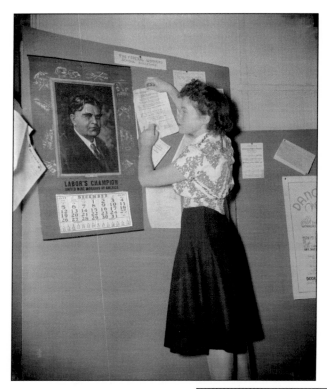

MARIAN HEPBURN, 1938. Here, 19-year-old Marian Hepburn, sister of movie and stage star Katherine Hepburn, had just taken a job with the United Federal Workers of America. In her third year at Bennington College in Vermont, Marian was considering the study of labor, government, and sociology. The Hepburns hailed from Fenwick, a borough in Middlesex County, Connecticut, in the town of Old Saybrook.

W. AVERILL HARRIMAN, 1913. Harriman served as secretary of commerce under Pres. Harry S. Truman and later as the 48th governor of New York. Few realize that after graduating, Harriman inherited the largest fortune in America and became Yale's youngest crew coach. In another Connecticut twist, Harriman's third and final marriage was in 1971 to Pamela Beryl Digby Churchill Hayward, the former wife of Winston Churchill's son Randolph and widow of Broadway producer Leland Hayward. Pictured here is the young and very sophisticated W. Averill Harriman in Connecticut on June 8, 1913.

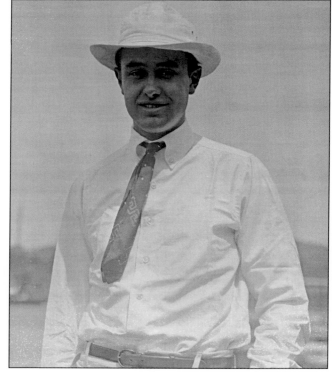

CHARLES E. HUGHES, 1940. On May 20, 1940, the US Supreme Court, under Chief Justice Charles E. Hughes (pictured), gave the unanimous opinion that applied to the states through the Due Process Clause of the 14th Amendment, the First Amendment's protection of religious free exercise. Before the *Cantwell v. Connecticut* decision, it was not legally clear that the First Amendment protected religious practitioners against restrictions at the state and local levels as well as federal.

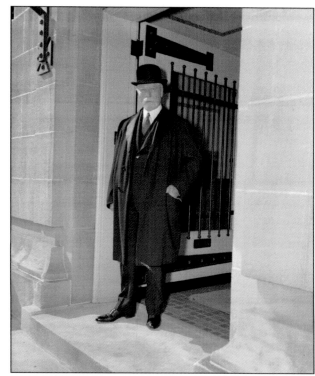

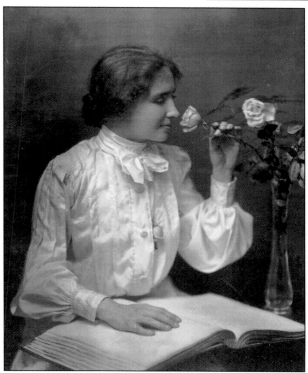

HELEN A. KELLER, 1904. Extraordinary in many ways, Helen Keller never allowed her monumental struggles to overshadow her unparalleled courage. Spending the final years of her life at Arcan Ridge in Easton, Connecticut, Keller was always quick to inspire during World War II. As the first woman to receive an honorary doctorate from Harvard University (1955), she was later awarded the Medal of Freedom (1964) from Pres. Lyndon B. Johnson.

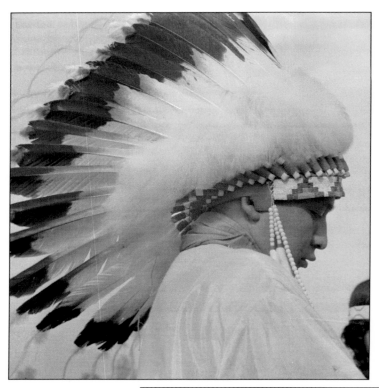

INDIAN/NATIVE AMERICAN ASSOCIATION HEADDRESS, 1941. Since Connecticut is derived from the Indian word Quinnehtukqut, meaning "beside the long tidal river," it was not a surprise to learn of the state's great appreciation for many tribes, including Mahican, Mohegan, Narraganset, Niantic, Nipmuc, Pequot, Schaghticoke, Wappinger, Golden Hill Paugussett, and others (variant spellings exist). According to resources, more than 44,000 Native Americans saw military service. Here, a Native American in Windsor Locks wears a beautiful headdress.

INDIAN/NATIVE AMERICAN ASSOCIATION, RELAXATION, 1941. Native Americans served on all fronts in the conflict and were honored by receiving numerous Purple Hearts, Air Medals, Distinguished Flying Crosses, Bronze Stars, Silver Stars, Distinguished Service Crosses, and three Congressional Medals of Honor. Here are two Native Americans sitting on a fence in Windsor Locks in 1941.

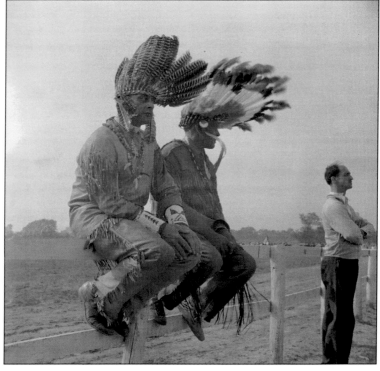

ERNEST J. KING, 1936. Rear Adm. Ernest J. King, completing his tour of duty as chief of the Navy's Bureau of Aeronautics, had a new flying flagship as he prepared to take over his role as commander of the aircraft base at San Diego. While other admirals had a floating flagship from which to direct maneuvers, Rear Admiral King would take to the air to direct his forces (1936). He was the recipient of three Distinguished Service Medals and commanded the Naval Submarine Base in New London (1923).

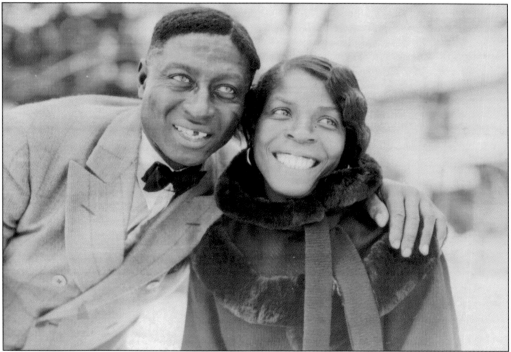

HUDDIE W. LEDBETTER, 1935. As an American folk and blues musician, Huddie "Lead Belly" Ledbetter became notable for his powerful vocals, virtuosity on the 12-string guitar, and the folk standards he introduced. He also played the piano, mandolin, harmonica, violin, and windjammer (diatonic accordion). Since his death on December 6, 1949, his songs "Goodnight, Irene," Cotton Fields," and "Midnight Special," to name only a few, have been covered by some of the finest musicians in history. He is pictured here in Wilton, Connecticut, with his wife, Martha Promise Ledbetter, whom he married in February 1935.

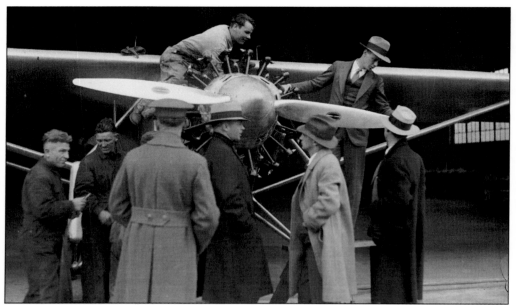

CHARLES A. LINDBERGH, 1927. Brainard Field (Hartford-Brainard Airport), centrally located in Connecticut, dates to 1921 and was said to be the first municipal airfield in the United States. Aviator Charles Lindbergh landed the *Spirit of St. Louis* there in July 1927 following his world famous transatlantic flight. Some 25,000 greeted him at the airfield and about 200,000 more witnessed Lindbergh as he rode through downtown Hartford. Here, spectators examine "Lucky Lindy's" plane. The logo on the propeller (Hamilton Standard Propellers, East Hartford, Connecticut) might look familiar to Connecticut residents.

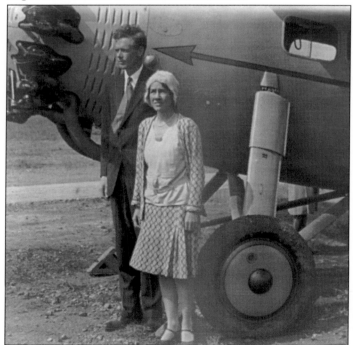

CHARLES A. LINDBERGH, 1929. While serving as a consultant, Charles Lindbergh lived with his family in Darien, Connecticut. Charles lived there quietly until his death in 1974, while Anne would live out her final years in their home that overlooked Long Island Sound.

JOE LOUIS BARROW, 1942. "We'll win, because we're on God's side" became a favorite wartime recruitment slogan thanks to Joseph Louis Barrow, the world heavyweight boxing champion. The military even chose to place the slogan on this poster. Barrow assisted recruitment efforts through three-round exhibitions, one of which occurred against Dee Amos in Hartford, Connecticut, on November 9, 1944. The "Brown Bomber" held the most elite title in boxing from 1937 to 1949.

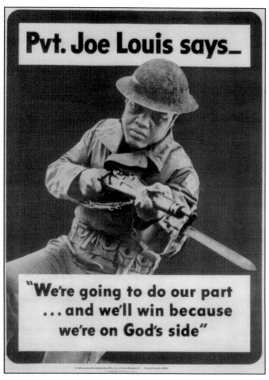

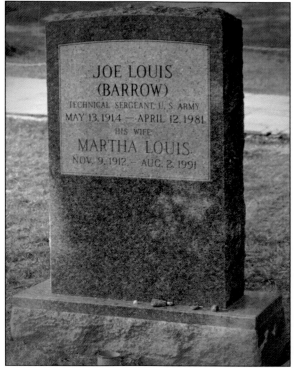

JOE LOUIS BARROW, 1981. Barrow died of cardiac arrest in Desert Springs Hospital near Las Vegas on April 12, 1981. Pres. Ronald Reagan waived the eligibility rules for burial at Arlington National Cemetery, and Barrow was buried there with full military honors on April 21, 1981. This side of his headstone notes his military service, while the other side includes a relief of the fighter and reads, "Louis, The Brown Bomber, World Heavyweight Champion 1937–1949." (Author's collection.)

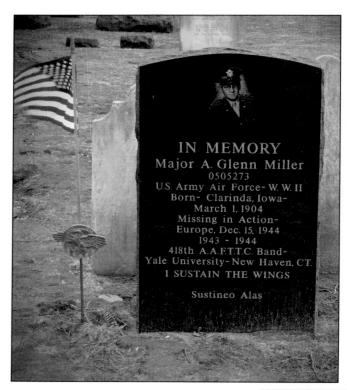

ALTON GLENN MILLER, 1999. Glenn Miller was not a stranger to anyone during World War II, and he was a neighbor to many people in this area. Appearing in Hartford, East Hartford, Meriden, Middletown, New London, Norwalk, Stamford, Wallingford, and Westville, Miller and his orchestra found a home in New Haven. From regular appearances on the New Haven Green to cadet luncheons at Woolsey Hall, the 418th Army Air Force Band could be heard over the airwaves and even on the sidewalks outside their rehearsal hall. Glenn Miller's memorial gravestone in New Haven's Grove Street Cemetery reminds everyone of his service. (Author's collection.)

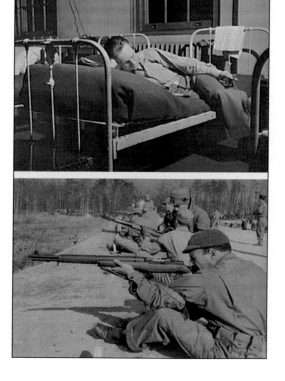

CONNECTICUT MEN AND WOMEN DURING THE WAR, 1942. They were "Our Boys" and "Our Girls," and Connecticut residents thought about them almost constantly, at times making it difficult to concentrate on the events at hand. Residents worried and prayed that those in harm's way would come home. Chaplain E.R. Taft (top), Episcopal, of Bridgeport, Connecticut, is studying for examinations in his bunk at the US Army chaplain school in Fort Benjamin Harrison, Indiana. Pvt. Paul Tellini (bottom) is on the rifle range at Fort Belvoir, Virginia. He was from Connecticut, and both of his parents were born in Italy.

CONNECTICUT MEN AND WOMEN AFTER THE WAR, 1941–1945. From the Japanese frontline in New Guinea—the world's second-largest island, just off the northern coast of Australia—comes the account of Sgt. Henry Francis Kirouac of Waterbury, Connecticut. When a lieutenant ordered Kirouac to have his men walk sentry duty along the top of a wall, the sagacious sergeant objected that his men would be easy targets. Such recalcitrance cost Kirouac a demotion. Thankfully, it was later overturned. For decades after the war, Sergeant Kirouac received dozens of holiday cards from thankful families of his men, from the soldiers themselves, and even the soldiers' great-grandchildren. (Courtesy of the Dennis DiGiovanni family.)

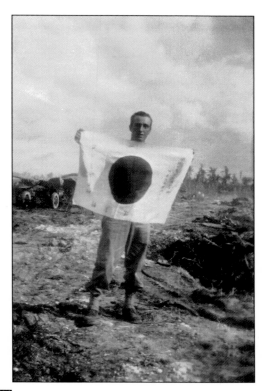

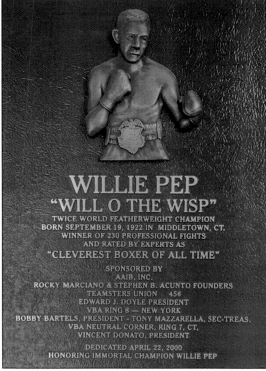

WILLIE PEP, 2000. Guglielmo Papaleo was born in Middletown, Connecticut, on September 19, 1922. Standing five feet, five and a half inches tall and weighing 126 pounds, he was not immediately noticeable, but when the featherweight was put inside the boxing ring everything changed, including his name. Willie Pep began his professional boxing career in 1940 and picked up a featherweight title a mere two years later. This Middletown, Connecticut, plaque hangs on the wall of the First & Last Tavern at 220 Main Street in tribute to the great boxer. (Author's collection.)

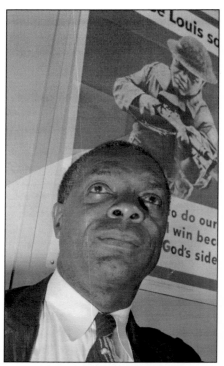

WILLIAM PICKENS, 1942. Pickens, the son of freed slaves, was the director of the interracial section of the Treasury Department's Saving Bonds Division from 1941 until 1950. It was this role during World War II that garnered him the respect of all races. His multifaceted education—he received bachelor's degrees from Talladega College (1902) and Yale University (1904), a master's degree from Fisk University (1908), and a doctor of letters from Selma University in 1915—only proved to enhance his brilliance. At a time when there were few African American leaders, his words spoke volumes.

AMERICAN RED CROSS, VOLUNTEERS/WORKERS AND CHAPTERS, 1942. At home, millions of American Red Cross volunteers provided comfort and aid to members of the armed forces and their families. There was simply not enough gratitude to extend to everyone involved with the organization. Pictured here are soldiers of the Iceland base command receiving gift boxes of sweaters and bags containing cigarettes, soap, sewing kits, and other comforts from the Cleveland, Ohio, and New Haven, Connecticut, Red Cross chapters.

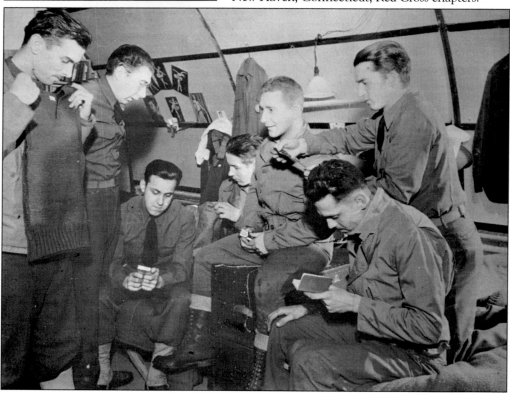

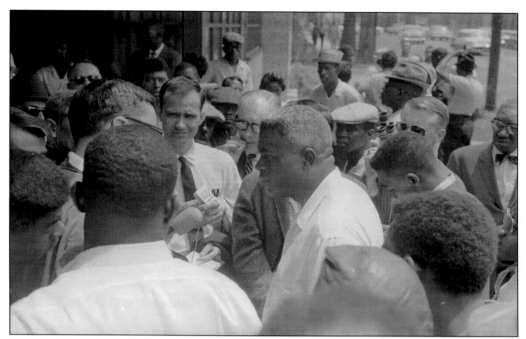

JACK R. "JACKIE" ROBINSON, 1963. Baseball legend and activist Jackie Robinson (pictured here speaking to reporters in Alabama) lived in Stamford, Connecticut, until his death in 1973 at the age of 53. From 1940 until 1960, Connecticut experienced a 44-percent growth in its white population compared to a 229-percent growth in its black population. However, despite the increase, many blacks, including the Robinsons, were subjected to racial prejudice and housing discrimination.

NORMAN P. ROCKWELL, 1900. Perhaps the most noted 20th-century American author, painter, and illustrator, Norman Rockwell's works enjoyed a broad popular appeal throughout the United States. His reflection of American culture included such images as Rosie the Riveter, The Problem We All Live With, Saying Grace, and the Four Freedoms series. Few realize that the artist's earliest American ancestor, John Rockwell (1588–1662), from Somerset, England, was one of the first settlers of Windsor, Connecticut.

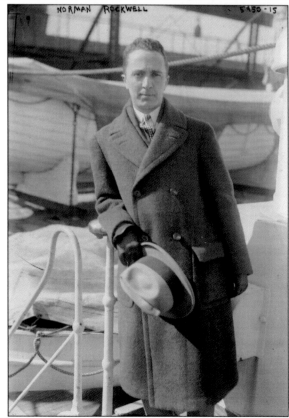

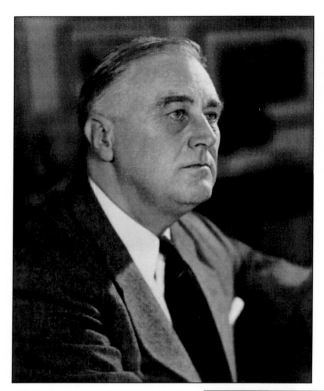

FRANKLIN D. ROOSEVELT, 1940. From March 1933 to June 1944, Franklin D. Roosevelt regularly addressed the American people through radio. Speaking on a variety of topics, the president's "fireside chats" tackled complex issues facing every resident of Connecticut while prompting renewed optimism and boundless patriotism.

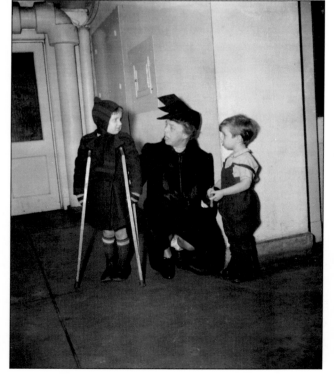

ANNA ELEANOR ROOSEVELT, 1939. She was simply extraordinary. From working with the American Red Cross during World War II to being the shoulder her husband needed most when he suffered a polio attack in 1921, Anna Eleanor Roosevelt welcomed every challenge she faced. The niece of Pres. Theodore Roosevelt and the distant cousin and wife to Pres. Franklin D. Roosevelt, she would redefine the role of the first lady.

SHIPPERS AND HANDLERS, PREPARATION, 1942. A completed Pratt & Whitney airplane engine, ready for installation, is prepared for shipment from a large eastern plant. The care taken in producing such fine engines extended even to their packaging. It was this commitment to quality assurance that enabled Connecticut products to arrive undamaged to the armed forces.

SHIPPERS AND HANDLERS, LOADING, 1942. Pictured is a single-row Pratt & Whitney airplane engine being loaded onto a freight car. This engine, one of the finest products of American manufacturing skill, would soon power a plane on one of the far-flung battlefronts.

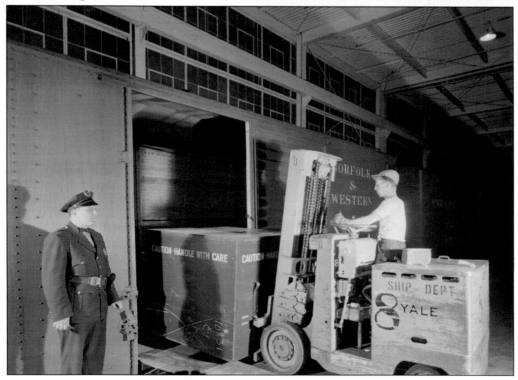

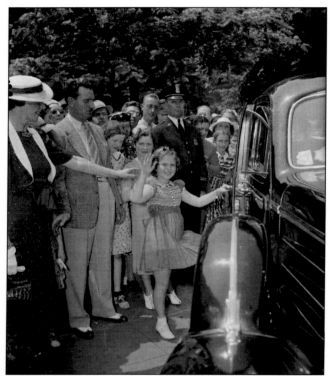

SHIRLEY TEMPLE, 1938. Shirley Temple is seen leaving the White House on June 24, 1938, after a very important conference. The actress, singer, dancer, businesswoman, and diplomat was Hollywood's number one box-office star from 1935 to 1938. She appeared in two 1944 wartime hits—*Since You Went Away* and *I'll Be Seeing You.*

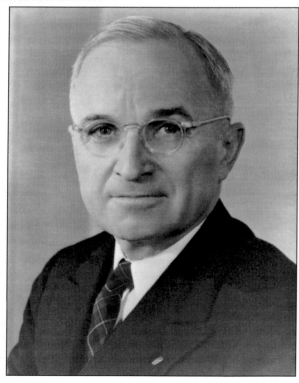

HARRY S. TRUMAN, 1945. Campaigning on October 28, 1948, in what would prove to be Truman's victory over Thomas E. Dewey (and one of the closest presidential elections in this country's history), the president made a stop in New London. "The 'Silent Service' never got the publicity that it deserved. But I know that the histories of this war will make it clear how great a part you people who built submarines, and the gallant submarine crews, had in winning the war," remarked Truman. From New London, he traveled to Bridgeport, then on to South Norwalk.

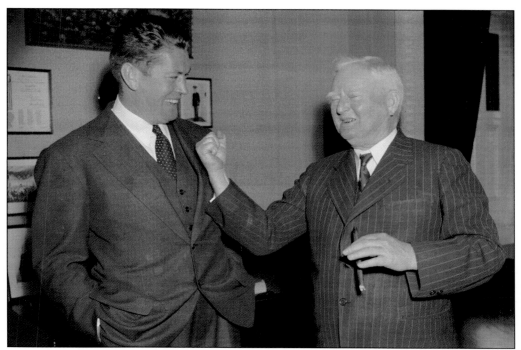

JAMES J. "GENE" TUNNEY, 1938. James Joseph "Gene" Tunney (1897–1978), pictured at left, was a professional boxer who held the world heavyweight boxing title from 1926 until 1928. Vice President Garner, pictured at right, displays his powerful "right" to the former champion during an impromptu visit to the Capitol. Tunney married wealthy socialite Mary "Polly" Lauder, and the couple raised three sons and one daughter at Star Meadow Farm in Stamford, Connecticut.

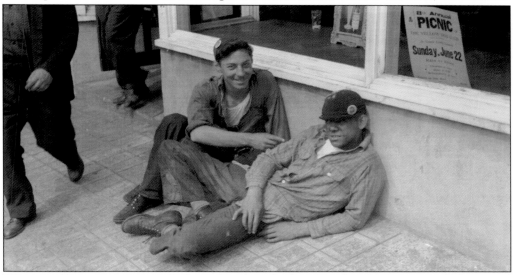

WORKERS, RELAXATION, 1941. Dedicated workers, both men and women, came in all shapes and size and were restricted, or so it would appear, only by a medical condition. If there was a place exemplary of the everyday worker during the war years it was Electric Boat Works in Groton. Here, the boys are just taking it a bit slow and easy during a 1941 shift change.

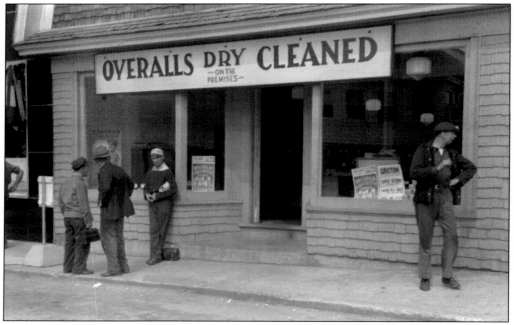

Workers, Contemplating Alternatives, 1941. If workers had the time to get their overalls cleaned, they might be able to pick up another shift. The local dry cleaners were more than happy to cater to the needs of Electric Boat Works employees.

Workers Waiting for Their Shift, 1941. Without question, the US military delivered on its promise during World War II, but so did those supporting on the home front. The author L. Frank Baum once quipped, "If I ever go looking for my heart's desire again, I won't look any further than my own back yard. Because if it isn't there, I never really lost it to begin with." Every Connecticut heart was with those in the armed services.

Three

PLACES

There were many words that you could not stand to hear and finally only the names of places had dignity. Certain numbers were the same way and certain dates and these with the names of the places were all you could say and have them mean anything. Abstract words such as glory, honor, courage, or hallow were obscene beside the concrete names of villages, the numbers of roads, the names of rivers, the numbers of regiments and the dates.

—Ernest Hemingway, A *Farewell to Arms*

It was not only the unique way they looked or sounded—that clanking of metal striking metal or the humming of a drill press or the cadence of a sewing machine—it was that smell. The fragrance left a taste in one's mouth. Those were the places recalled by Connecticut residents during World War II, and they seemed to turn the senses inside out.

There was the Farrel Corporation in Ansonia, the Warren McArthur plant in Bantam, even the Levine and Levine Company in Colchester. They were all companies that built towns, or was it the other way around?

People traveled from near and far to work at Hamilton Standard or Pratt & Whitney in East Hartford—some from Hartford even lived across the street in trailer camps.

Remember that?

The war effort brought together folks from across the state. A few worked in the tobacco farms out at Warehouse Point for Fred Schenleber, and others were employed by the Palmer brothers in Fitchville. Name a town, and more than likely, people knew someone from there.

Connecticut residents saved their money. When they had enough, which was a special occasion, some took the bus into downtown Hartford and shopped at G. Fox & Company—a department store that created a majestic view along Main Street. When Christmas rolled around, the store would put out spectacular displays. Naturally, everyone knew Santa lived on the 11th floor. To some, the store smelled like perfume, but it really all depended on what department one was in. Shoppers never worried much about dragging items home, as the store had a policy of free deliveries.

When shoppers were downtown, they might eat at Lindy's over on Trumbull Street. All their hot sandwiches came with Lindy's special gravy, which everyone loved. And all their sandwiches were only 75¢. During the holidays, a thirsty patron might splurge and have a sherry or brandy "flip." Flips were a little like eggnog (a spirit, egg, cream, sugar, and spice). It is funny what people recall about a place, isn't it?

ANSONIA, NEW HAVEN COUNTY, 1940. Based in Ansonia, the Farrel Corporation manufactured equipment for the plastics industry. During World War II, the Navy contracted with Farrel-Birmingham and General Motors to begin manufacturing a rapid reversal gear system that would allow vessels to reverse engines without first slowing down. The following year, both companies received the prestigious E award, for "Excellence in Production," from the Navy for their efforts. Employees are pictured here during a shift change outside the plant.

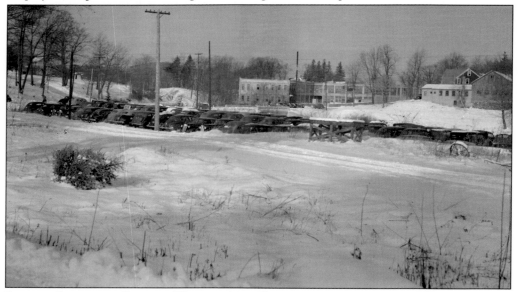

BANTAM, LITCHFIELD COUNTY, WINTER 1942. The Warren McArthur Corporation, pictured in the background, was a furniture company that specialized in aluminum pieces. The cars in the foreground belonged to workers at the plant, at least half of whom commuted from nearby towns and cities. Bantam had a population of only 564 in 1940.

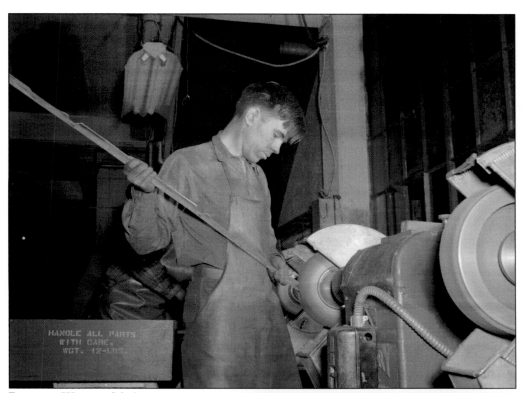

BANTAM, WARREN MCARTHUR CORPORATION, 1942. Buffing aluminum supports for bomber seats was a common task for 19-year-old Gerard Gervais. He traveled to Bantam in the fall of 1941 along with his older brother Ernest all the way from Plainfield, Connecticut. The two brothers shared a five-room house in Bantam with two aunts and an uncle, who were also employed by the Warren McArthur plant. This was another excellent example of how Connecticut families bonded together in support of the war effort.

BANTAM, DANTE ELECTRIC COMPANY, 1942. In 1942, Anna Dante, of the Dante Electric Company, is punching holes in electrical terminals with a power press. During World War II, many male workers marveled at her proficiency on a variety of the manufacturing tools. It was another example of the enormous contribution of Connecticut women.

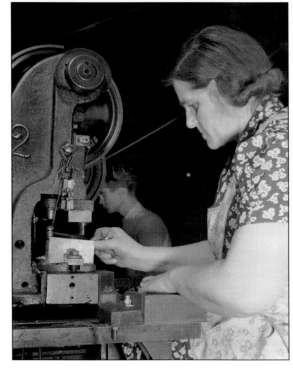

BANTAM, BUSINESS SECTION, 1942. This view shows the business section of Bantam on Bantam Road (Route 202). The block of stores on the left included Mitchell's Tavern, the First National Store, a garage, and two service stations. At right was the Episcopal church, Tony's Bantam Inn, Marcel Roy's drugstore, the Bantam grocery store, and the firehouse.

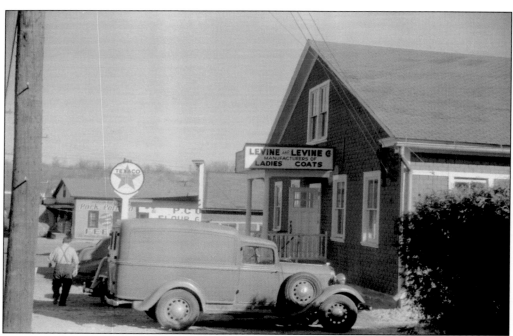

COLCHESTER, NEW LONDON COUNTY, 1940. Traditionally a small, quiet town, Colchester was about to increase its population from 2,338 in 1940 to 3,007 by 1950. For many local Jewish farmers, part-time work in local industries such as the Levine and Levine Company, manufacturers of ladies' coats, provided much needed income.

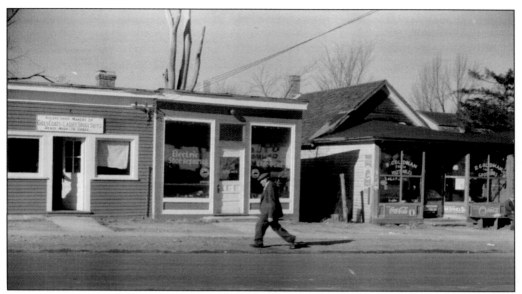

COLCHESTER, ADLER'S SHOP, 1940. One quarter of the town of Colchester was Jewish in 1940, down from half in 1920. Land was cheap in Connecticut and assistance was available for Jewish immigrants who wanted to leave New York's East Side in favor of life in a small town. Jewish farmers also settled in Norwich, East Haddam, and Newtown, close enough to New York to maintain social ties and business relationships. This view shows Adler's Shop, makers of girl's coats and ladies sport suits, and Felner's Electric Shoe Repairing.

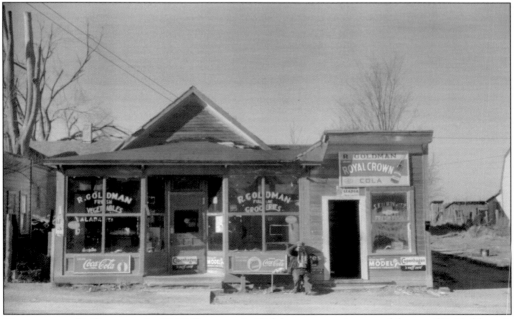

COLCHESTER, R. GOLDMAN'S, 1940. Everyone in Colchester, or so it seemed, knew of R. Goldman's groceries. At right, note the S. Kalmonwitz "Fresh Fish" shop. Metal signs were a common form of advertising, particularly with soft drink manufacturers. Royal Crown Cola was a popular drink that had been reformulated from Chero-Cola in 1934.

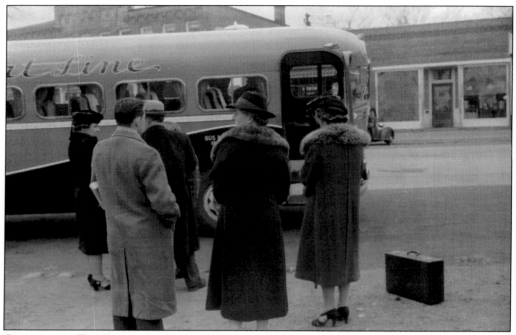

COLCHESTER TRANSPORTATION, 1940. Getting the bus in Colchester and then heading off to Hartford was a daily occurrence for many townsfolk. This was an era that saw the last of the Connecticut trolleys ceasing operation and being replaced by diesel buses.

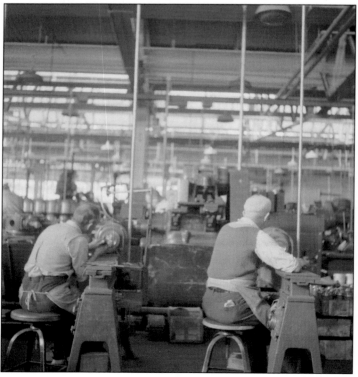

EAST HARTFORD, HARTFORD COUNTY, 1940. Hamilton Standard, an aircraft propeller parts supplier, was a division of United Aircraft Corporation, along with Pratt & Whitney, and is now UTC Aerospace Systems. It was established in 1929 when United Aircraft and Transport Corporation consolidated Hamilton Aero Manufacturing and Standard Steel Propeller into the Hamilton Standard Propeller Corporation. Here, experienced craftsmen at Hamilton display their skills in East Hartford just prior to the beginning of World War II.

EAST HARTFORD, HAMILTON STANDARD, 1940. There was an art to balancing a propeller inside Hamilton's East Hartford plant. The company was the largest manufacturer of aircraft propellers in the world.

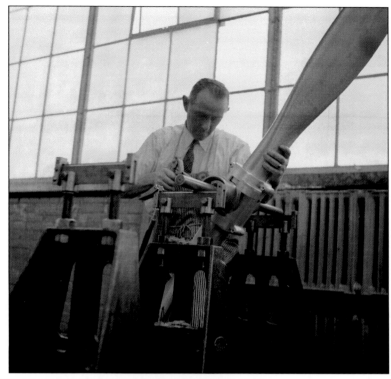

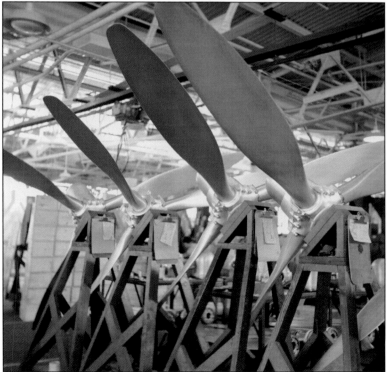

EAST HARTFORD, PROPELLER MANUFACTURING, 1941. At this stage, a group of finished propellers at Hamilton's East Hartford plant awaits the next phase of production. Charles Lindbergh's *Spirit of St. Louis* used a propeller made by the Standard Steel Propeller Company, a forefather of Hamilton, in his historic solo crossing of the Atlantic Ocean.

INTERNATIONAL HISTORIC MECHANICAL ENGINEERING LANDMARK

HAMILTON STANDARD HYDROMATIC PROPELLER

WINDSOR LOCKS, CONNECTICUT

LATE 1930s

THE VARIABLE-PITCH AIRCRAFT PROPELLER ALLOWS THE ADJUSTMENT IN FLIGHT OF BLADE PITCH, MAKING OPTIMAL USE OF THE ENGINE'S POWER UNDER VARYING FLIGHT CONDITIONS. ON MULTI-ENGINED AIRCRAFT IT ALSO PERMITS FEATHERING THE PROPELLER -- STOPPING ITS ROTATION -- OF A NON-FUNCTIONING ENGINE TO REDUCE DRAG AND VIBRATION.

THE HYDROMATIC PROPELLER WAS DESIGNED FOR LARGER BLADES, FASTER RATE OF PITCH CHANGE, AND WIDER RANGE OF PITCH CONTROL THAN EARLIER CONTROLLABLE-PITCH PROPELLERS. THE HYDROMATIC PLAYED A DISTINGUISHED ROLE IN ALLIED COMBAT AIRCRAFT IN WORLD WAR II. ITS CONTINUING DEVELOPMENT HAS INCORPORATED MANY FEATURES USED ON LATER AIRCRAFT, INCLUDING TODAY'S TURBOPROP PLANES.

THE AMERICAN SOCIETY OF MECHANICAL ENGINEERS - 1990

EAST HARTFORD, ENGINEERING DESIGN, 1990. This plaque from the American Society of Mechanical Engineers acknowledges the Hamilton Standard Hydromatic Propeller. (Courtesy of the New England Air Museum, Windsor Locks, Connecticut.)

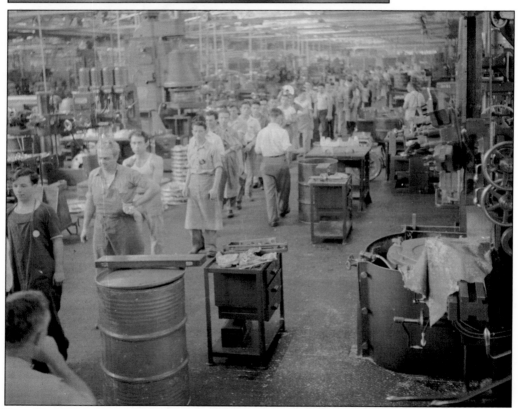

EAST HARTFORD, PRATT & WHITNEY, 1941. This was the 3:00 p.m. shift on the way out of the Pratt & Whitney Aircraft Corporation in East Hartford. It was a regimented manufacturing environment designed for productivity. The story goes that Frederick Rentschler persuaded the board of Niles Bement Pond that their Pratt & Whitney Machine Tool subsidiary in Hartford should provide the funding and location to build a new aircraft engine being developed by Rentschler, aircraft engineer George J. Mead, and colleagues, all formerly of Wright Aeronautical, as in the Wright brothers. They agreed and lent Rentschler $250,000, the use of the name, and materials.

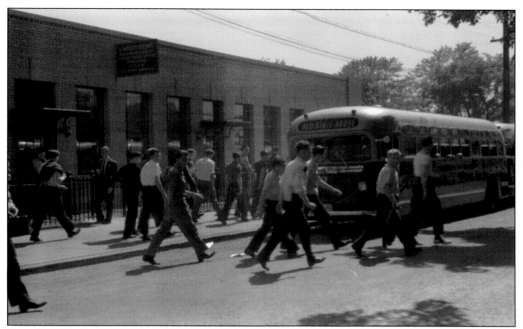

EAST HARTFORD, CHANGE OF SHIFT, 1941. Once outside the East Hartford plant, Pratt & Whitney workers scrambled in every direction toward available transportation. It seemed employees were never far from an engine. The company's first aircraft engine, the 425 horsepower R-1340 Wasp, was completed on Christmas Eve in 1925. That same mechanism powered the aircraft of Wiley Post, Amelia Earhart, and many others on record-setting flights.

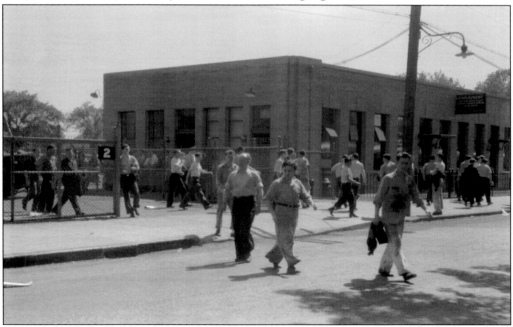

EAST HARTFORD, HEADING HOME, 1941. It is likely that every resident, not to mention business, of East Hartford knew when Pratt & Whitney's shift changes took place.

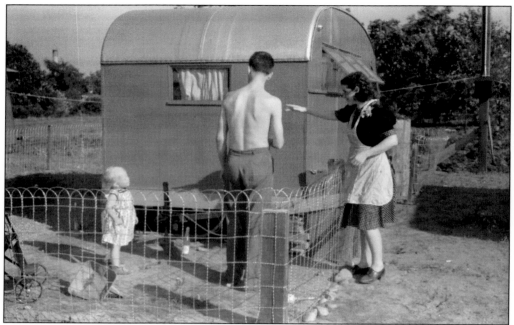

EAST HARTFORD, HOUSING CRISIS, 1941. From 1940 to 1950, East Hartford experienced its largest population growth of the 20th century and with it a need for housing. Trailer camps, such as the one pictured here, were set up to house families.

EAST HARTFORD, TRAILER CAMP, 1941. Trailers were actually parked opposite the Pratt & Whitney aircraft plant. This was a convenience for plant employees, but meant a lack of privacy for their families.

EAST WINDSOR, HARTFORD COUNTY, 1940. East Windsor had five villages: Broad Brook, Melrose, Scantic, Warehouse Point, and Windsorville. But it was Warehouse Point that was known for its tobacco farms. Employing a crew of 30, Fred Schoenleber, pictured here in 1940, was one of those who farmed 36 acres of tobacco.

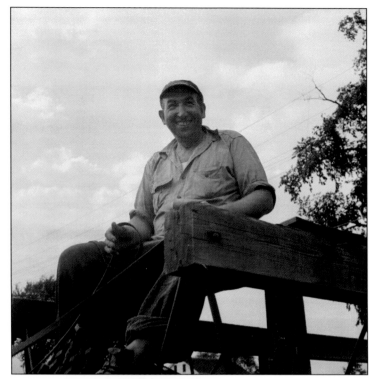

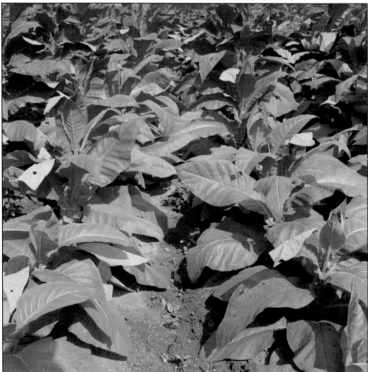

EAST WINDSOR, WAREHOUSE POINT, 1940. Pictured is the tobacco produced by a state that ranked consistently in the top in domestic production. By virtue of its location on the Connecticut River, Windsor was once a vital port. Merchants on both sides of the river shipped timber products, brick, livestock, wheat, tobacco, and other produce to supply plantations primarily in the West Indies.

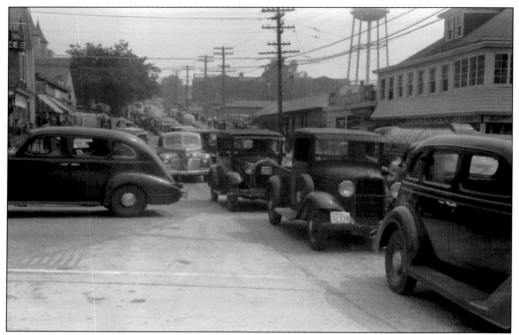

GROTON, NEW LONDON COUNTY, 1941. General Dynamics Electric Boat, also known as Electric Boat, is a subsidiary of General Dynamics Corporation and has been the primary builder of submarines for the US Navy for more than 100 years. Traffic congestion, as pictured here, was an afternoon dilemma for everyone in town.

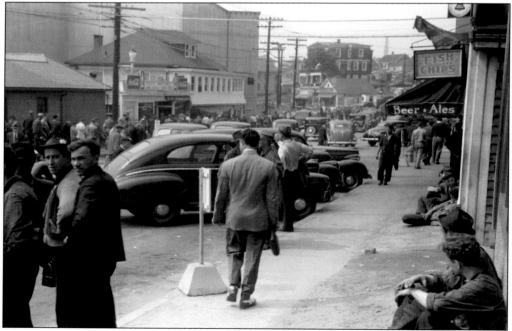

GROTON, AFTERNOON RUSH, 1941. Groton thrived during World War II, and employees at the Marine Bar & Grill knew exactly when the afternoon rush was about to occur.

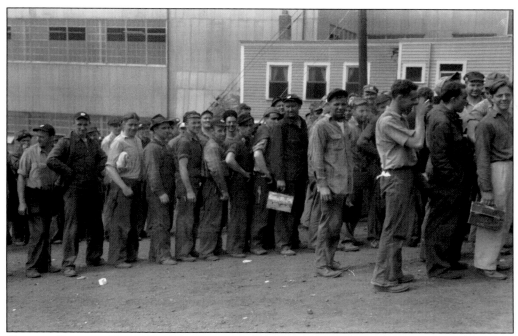

GROTON, ELECTRIC BOAT, 1941. Let's move it along boys! Groton's population increased over 100 percent from 1940 to 1950. During World War II, the company, which ranked 77th in military contract value, built 74 submarines, while Elco, a subsidiary, constructed nearly 400 PT boats.

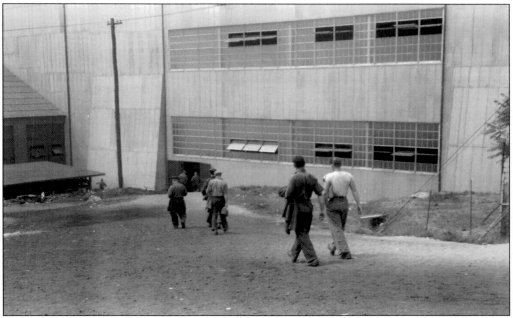

GROTON, FACTORY PRODUCTION, 1941. Here, Electric Boat workers are filing into the plant during another shift change. As the heat inside the factory could be oppressing, factory windows were opened to improve ventilation. In a testament to Connecticut productivity, Electric Boat could complete a submarine every two weeks, if needed.

SUPER .38 AUTOMATIC PISTOL

CALIBER .38

For the big game hunter, and the lover of the out-
doors, the Super .38 offers an arm of unsurpassed
power and efficiency. It is built on the same frame
as the Government Model and has all of the safety
features found in this famous gun. It is especially
popular because of the powerful Super .38 cartridges
which it handles — having a muzzle velocity of
approximately 1,300 foot seconds. Will stop any
animal on the American continent and is a favorite
for use as an auxiliary arm for big game hunting.
Magazine holds 9 cartridges.

SPECIFICATIONS

Ammunition: .38 Automatic cartridges.
Magazine Capacity: 9 cartridges.
Length of Barrel: 5 inches.
Length Over All: 8½ inches.
Weight: 39 ounces.
Sights: Fixed Partridge type. Striped.
Trigger and Hammer Spur: Checked.
Arched Housing: Checked.
Stocks: Checked Walnut.
Finish: Blued. Can be furnished in Nickel Finish
at extra cost.

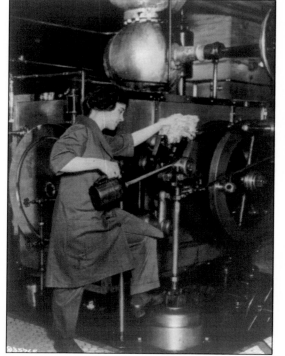

HARTFORD, HARTFORD COUNTY, 1900.
Filling orders for the war occupied so
much time for Colt Manufacturing
Company that it ceased production of
its popular Single Action Army revolver.
The company focused on the production
M1911A1 pistols as well as a large number
of M1917 water-cooled machine guns.
Producing over 600,000 quality M1911A1
pistols earned it the Army-Navy rating of
"E" for excellence. This was Colt's armory
in Hartford. (LC-DIG-det-4a12213; insert
from 1941 catalog advertisement.)

**HARTFORD, COLT MANUFACTURING
COMPANY, 1914.** With a workforce of
15,000 men and women operating in
three factories, Colt operated production
around the clock to fulfill demand.
And what a job the company did! A
woman oiling a piece of manufacturing
equipment was not an unusual sight.

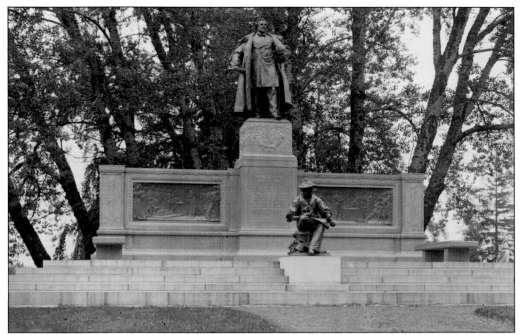

HARTFORD, SAMUEL COLT MONUMENT, 1907. This Hartford monument reads: "Samuel Colt, 1814–1862, on the grounds which his taste beautified by the home he loved this memorial stands to speak of his genius his enterprise and his success and of his great loyal heart."

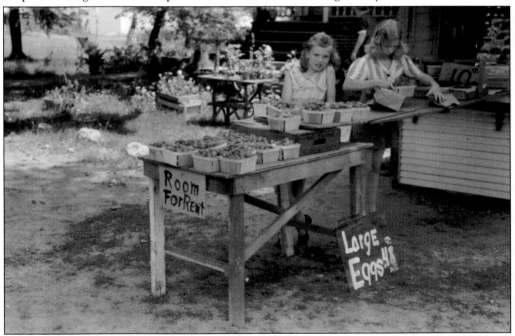

HARTFORD, FRUIT STAND, 1941. As manufacturing boomed in Connecticut during World War II, housing was at a premium. Here, at a Hartford fruit stand, it was advantageous to pay attention to the signs.

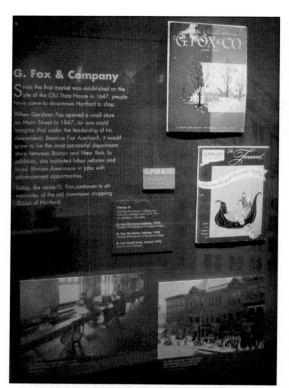

HARTFORD, G. FOX AND COMPANY, 1993. Downtown Hartford was once the place to shop, and it was G. Fox and Company that added the definitive article. For decades, it was a symbol of Connecticut's capital city and its premier department store. Beginning as a small store on Main Street in 1847, G. Fox and Company grew to be the most successful department store between Boston and New York. (Courtesy of Connecticut's Old State House.)

HARTFORD, DEPARTMENT STORE ARTIFACTS, 1993. Pictured here are a G. Fox and Company clothes label, the landmark building sign, and a souvenir matchbook. (Author's collection; building sign courtesy of Connecticut's Old State House.)

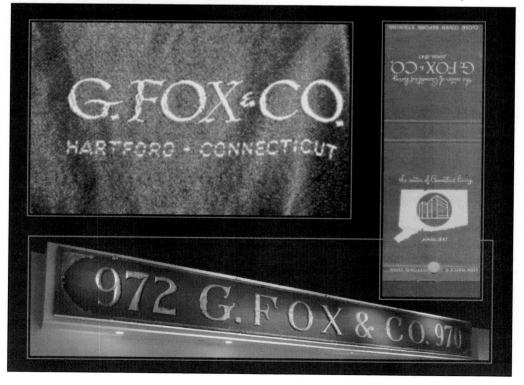

HEBRON, TOLLAND COUNTY, 1945. The Civilian Defense Aircraft Observation Post 52 provided an invaluable service during World War II, not to mention a sounder sleep to Tolland County citizens. Manned around the clock, this structure was built on Post Hill in Columbia and later moved to nearby Hebron after the war. A last-of-its-kind facility, it can now be visited at Hebron's Town Office Building complex at 15 Gilead Street (Route 85). (Author's collection.)

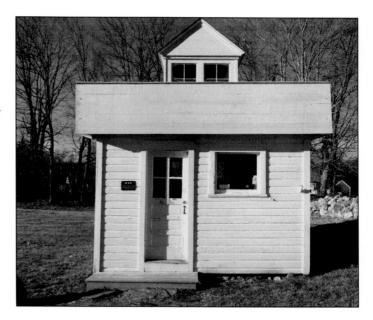

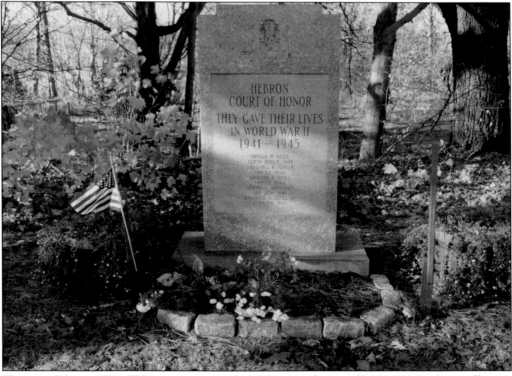

HEBRON, WORLD WAR II MONUMENT, 1945. With a population of 999 in 1940, the small town of Hebron, which would grow to 1,320 by 1950, was indicative of the patriotism felt throughout Connecticut. To this day, this timeless town monument reminds residents of the ultimate sacrifice given by area families. (Author's collection.)

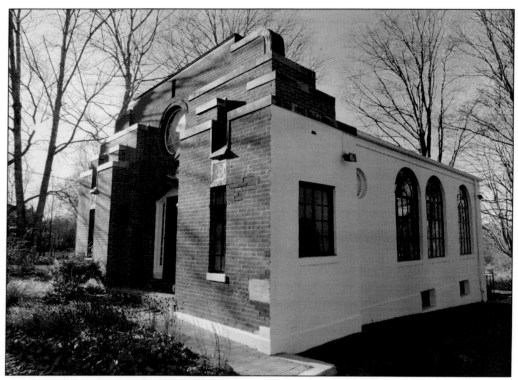

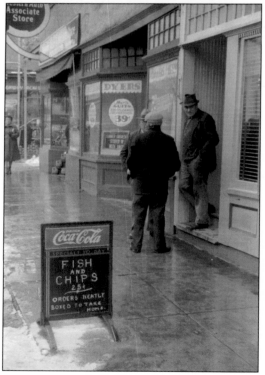

HEBRON, SYNAGOGUE, 1940. The United Brethren of Hebron Synagogue, pictured here, was erected on Church Street in 1940. Many a prayer was said in this beautiful Art Deco structure during World War II. The structure was a vision of Ira Turshen, who many knew as owner of the general store and grain mill in nearby Amston. (Author's collection.)

JEWETT CITY, NEW LONDON COUNTY, 1940. Jewett City, in the town of Griswold, was named after 1771 founder Eliezer Jewett. Pictured here are men, perhaps nearby Norwich workers, outside a local establishment in 1940. Note that Dyers was offering men's suits dry cleaned and pressed for 39¢. Fish and chips were the special, at 25¢, with "orders neatly boxed to take home."

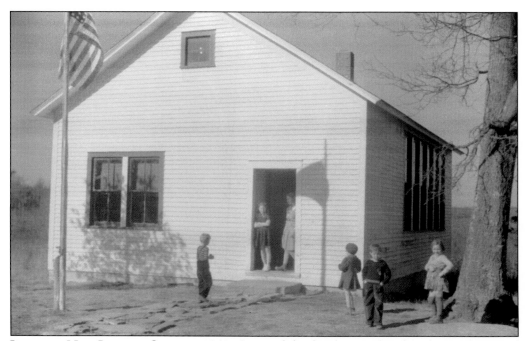

LEDYARD, NEW LONDON COUNTY, 1940. Some of the families employed at the nearby Naval Submarine Base New London found solace living in the community of Ledyard. In 1940, the population was only 1,426, while today it is over ten times that. Pictured here during a simpler time are small children from Ledyard waiting for their older brothers and sisters to be let out of school for lunch.

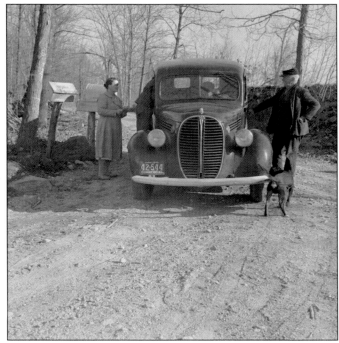

LEDYARD, MAIL DELIVERY, 1940. In 1940, rural mail delivery in Ledyard often meant a bit of casual conversation and perhaps even a visit from the family dog. The mail carrier was often a source of area news and a way to stay in touch with the community, so being on a first-name basis with him was a smart move.

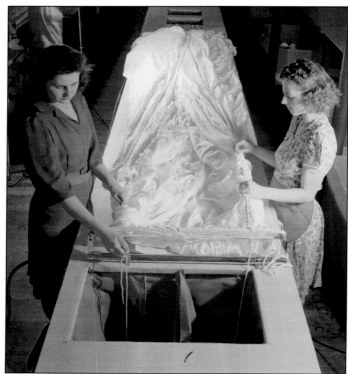

MANCHESTER, HARTFORD COUNTY, 1942. Manchester is often remembered for the Cheney brothers—Ward, Frank, and Rush—and their silk processing business. In 1938, the company partnered with DuPont and the Army Air Force to develop a new parachute, which was produced by Cheney's newest subsidiary—Pioneer Parachute. Here, two women, working at the new branch, thread shroud cords through yards of silk that will become more recognizable as one of the company's parachutes.

MONTVILLE, NEW LONDON COUNTY, 1940. Halfway between the cities of Norwich and New London rests Montville, pictured here, one of 21 towns in New London County. With a population of 4,135 in 1940, the town had experienced relatively consistent growth leading up to World War II.

MONTVILLE, WORKING CLASS, 1940. By 1935, almost 40 percent of the families inhabiting the town were foreign. Immigration played an important role in the development of Montville. Pictured here in front of his house is an anonymous French Canadian who was said to have worked in a paper mill in Montville for 11 years.

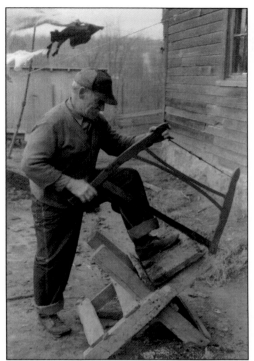

NEW HAVEN, NEW HAVEN COUNTY, c. 1969. In 1950, New Haven reached the pinnacle of its population growth. Nowhere was the movement of people and materials more evident than in the rail yards. The Work Equipment Shop, pictured here, saw an increased investment in the New York, New Haven & Hartford Railroad's facilities in the period immediately following World War II. In addition to this shop, the railroad used some of the money it earned in wartime service to construct large modern buildings for storage and diesel maintenance. The steel framing of the shop was characteristic of mid-20th-century industrial construction.

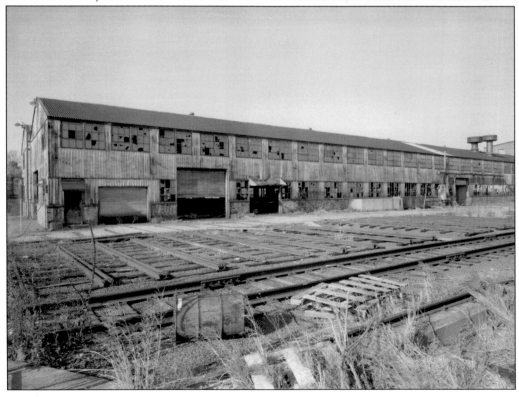

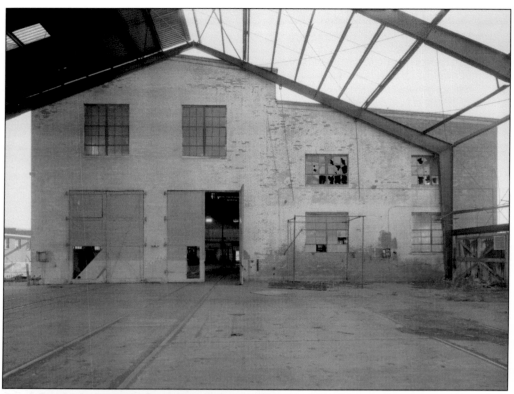

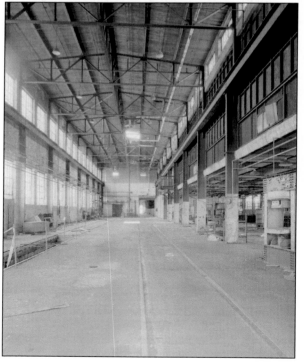

NEW HAVEN, SOUTHWEST VIEW OF RAIL YARD, C. 1969. This view, looking southwest, shows the New Haven Rail Yard Work Equipment Shop in the vicinity of Cedar and Lamberton Streets in New Haven. The popular author Laura Ingalls Wilder, known for her *Little House on the Prairie* book series, once noted, "These times are too progressive. Everything has changed too fast. Railroads and telegraph and kerosene and coal stoves—they're good things to have, but the trouble is, folks get to depend on 'em."

NEW HAVEN, EQUIPMENT SHOP, C. 1969. An interior view, looking southwest, shows the New Haven Rail Yard Work Equipment Shop, in the vicinity of Cedar and Lamberton Streets in New Haven.

NEW LONDON, NEW LONDON COUNTY, c. 1969. Planned and built by the US Maritime Commission as part of the Officers Service School, Bowditch Hall provided classroom and auditorium space for the facility. In later years, it housed a variety of laboratories and computing spaces. This view was 600 feet east of Smith Street and 350 feet south of Columbia Cove on the west bank of the Thames River in New London.

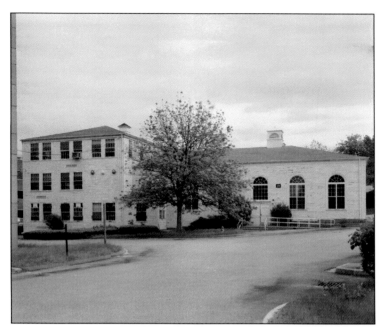

NEW LONDON, OFFICERS SERVICE SCHOOL, c. 1969. This view is west of Bowditch Hall, 600 feet east of Smith Street and 350 feet south of Columbia Cove on the west bank of the Thames River in New London. As with the other military services, the entry of the United States into World War II necessitated the immediate growth of the Merchant Marine and the Coast Guard.

NEW LONDON, BOWDITCH HALL, C. 1969. This was the entry to the auditorium at Bowditch Hall. The facility was significant as a key element of the World War II Maritime Officer's School and as laboratory space used during the Cold War. The maritime service established several training centers throughout the United States and two officers' candidate schools—one of which was Fort Trumbull, Connecticut, from 1939 until 1946.

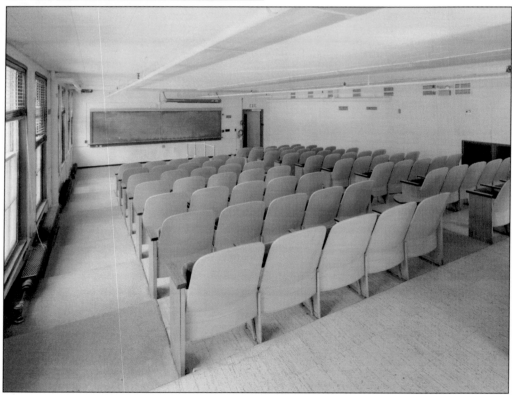

NEW LONDON, CLASSROOM, C. 1969. This is a look inside a Bowditch Hall classroom at what would later be known as the Naval Undersea Warfare Center.

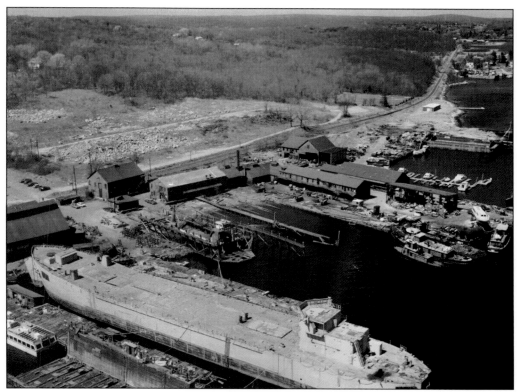

NORWICH, NEW LONDON COUNTY, c. 1969. The Thames Towboat Company was incorporated in Norwich, Connecticut, on December 29, 1865. Edward Chappell and others built it into one of the most prestigious businesses along the river and New London Harbor. Its shipyard served as a submarine maintenance base in World Wars I and II. This is a 1969 aerial view from southwest of the company, at the foot of Farnsworth Street in New London.

NORWICH, AERIAL VIEW, c. 1969. This aerial view is from the south of Thames Towboat Company, at the foot of Farnsworth Street in New London. For years, it remained a surviving example of wooden shipbuilding and a busy repair facility. It also contained the oldest known steam-powered marine railway in the United States.

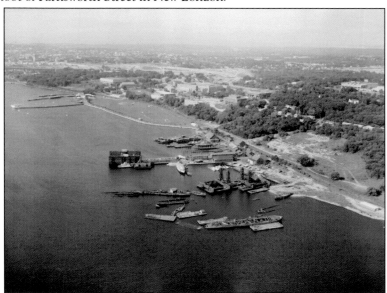

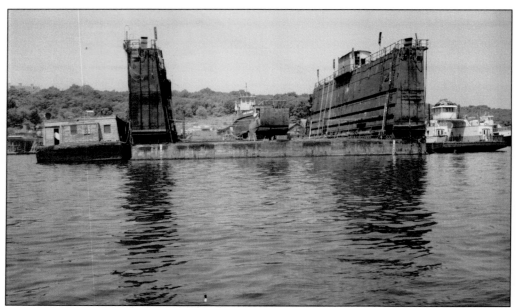

NORWICH, DRYDOCK, C. 1969. Pictured is the Thames Towboat Company's floating dry-dock, a dock that can be drained of water to allow the inspection and repair of a ship's hull.

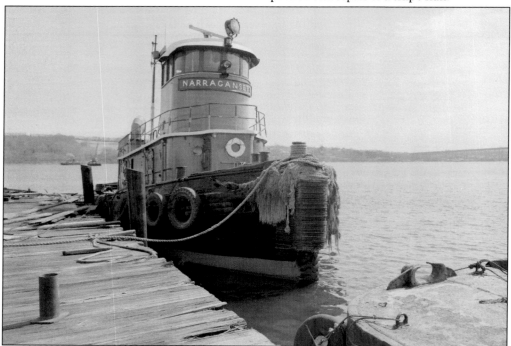

NORWICH, PIER NO. 5 WITH TUGBOAT, C. 1969. The Thames Towboat Company's Pier No. 5 is pictured here in 1969 with the tug *Narragansett* tied to it. Powerful for their size, tugboats push or tow vessels that either should not move by themselves, such as ships in a crowded harbor or a narrow canal, or those that could not move by themselves, such as barges, disabled ships, log rafts, or oil platforms.

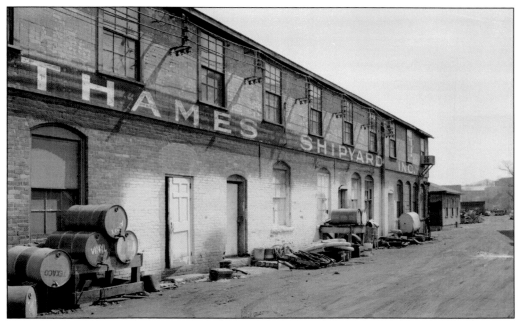

NORWICH, RAILWAY HEAD HOUSE, C. 1969. This image of the Marine Railway Head House and Offices was taken from the west side. The railroad term "head house" often referred to a part of a train station that does not house the tracks and platforms.

NORWICH, FRUIT STAND, 1940. Fresh fruit stands were popular in many Connecticut cities, such as Norwich. In 1939, according to the US Department of Commerce, Connecticut produced over two million quarts of strawberries, over a million bushels of apples, nearly a million pounds of grapes, and over 80,000 quarts of red raspberries.

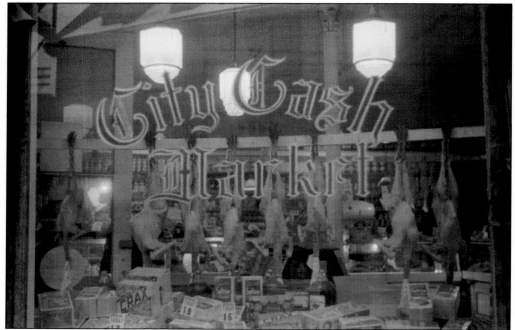

NORWICH, CITY CASH MARKET, 1940. In 1940, fresh poultry hanging from the meat rack typically caught many an eye from a casual shopper at the City Cash Market. With the growth of automobile ownership and suburban development, supermarkets proliferated across the United States after World War II. They put an end to many mom-and-pop and corner grocery stores.

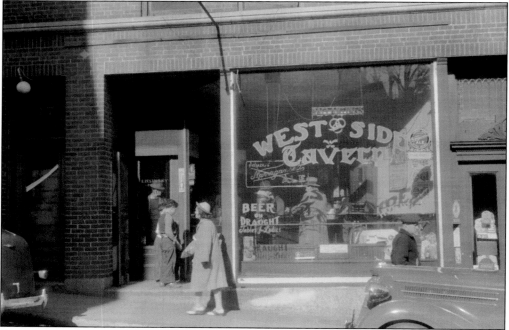

NORWICH, 1940. Not only did they have "Beer On Draught" at the West Side Tavern in 1940 but also "Tables for Ladies."

NORWICH, STREET SCENE, 1940. Norwich is still known as "The Rose of New England," but in 1940, it was home to only 23,652 citizens. Gone are the days when one could grab a "Full Course Thanksgiving Dinner" for 75¢. The thermometer, which often received as many glances as the window specials, was from Norwich Auto Radiator & Body Works at 165 Main Street.

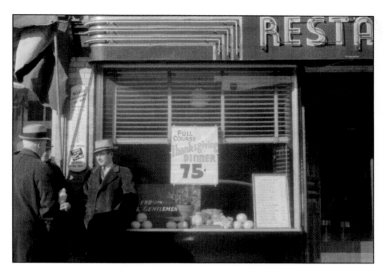

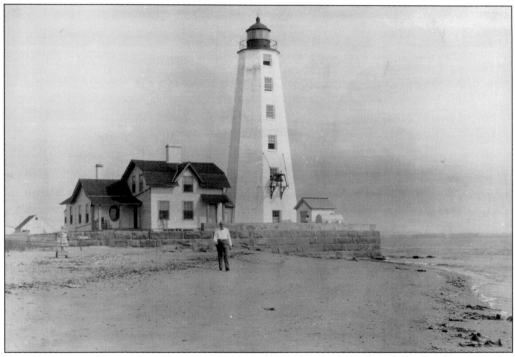

OLD SAYBROOK, MIDDLESEX COUNTY, 1940. Designed to be a leading light for ships coming through Long Island Sound, the Lynde Point Lighthouse marked the entrance to the Connecticut River. However, the original wooden structure was often criticized for not being tall enough and built too close to marshland. Both characteristics diminished its effectiveness, so a new 65-foot granite tower was erected in 1838 and lit in 1839. The light's visual range was 14 nautical miles, and it was not electrified until 1955. The lighthouse, now managed by the US Coast Guard, is adjacent to a neighborhood of large homes, including the longtime home of the late actress Katharine Hepburn.

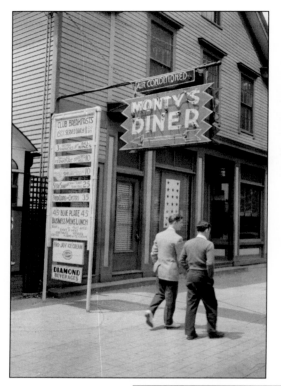

SOUTHINGTON, MONTY'S DINER, 1942.
From Club Breakfasts, served daily from 6:00 a.m. until 11:00 a.m., to three-decker sandwiches and Fro-Joy ice cream, if anyone needed nourishment in 1942, Monty's Diner in Southington could satisfy their hunger. After World War II, Southington developed into a bedroom community, and the population soared to over 13,000 by 1950. Today, the population is over three times that figure.

SOUTHINGTON, CLASSROOM, 1942. This classroom, located in Southington, likely resembles most of its day, with shelves packed with reference books and a bulletin board reflective of the times.

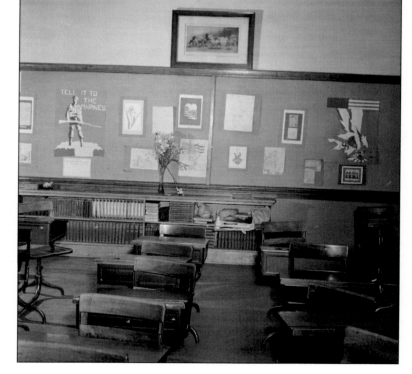

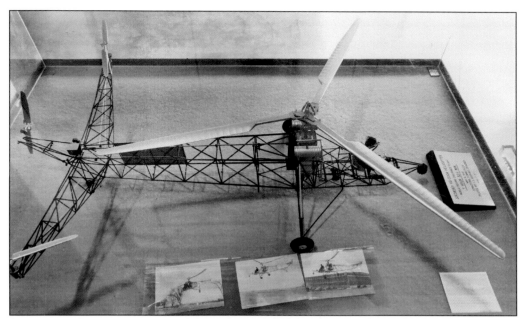

STRATFORD, FAIRFIELD COUNTY, 1941. This is a model of the Sikorsky VS-300A helicopter. The original was piloted by designer Igor Sikorsky himself on May 6, 1941. Sikorsky was a Russian American aviation pioneer in both helicopters and fixed-wing aircraft. He would modify the design of VS-300 in favor of the Sikorsky R-4, which became the world's first mass-produced helicopter in 1942. (Courtesy of the New England Air Museum, Windsor Locks, Connecticut.)

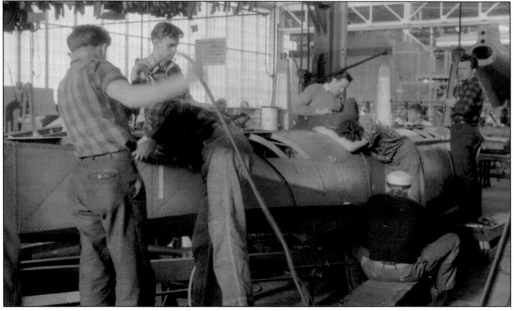

STRATFORD, MANUFACTURING, 1940. This is a pontoon, or buoyant device, being constructed at the Vought-Sikorsky Aircraft Corporation in Stratford. Sikorsky used such devices on his S-42 commercial flying boat that he built for Pan American World Airways in 1931. Vought, named after founder Chance M. Vought, was part of United Aircraft, which moved to Stratford in 1939.

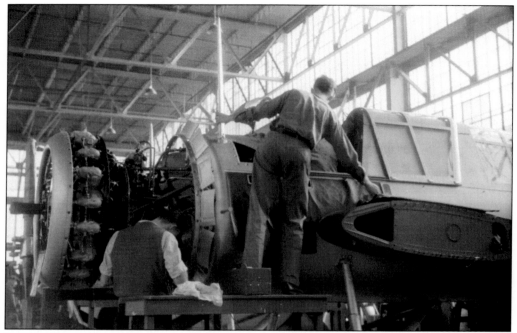

STRATFORD, SIKORSKY AIRCRAFT CORPORATION, 1940. Immigrating to the United States in 1919, Sikorsky founded the Sikorsky Aircraft Corporation four years later. Pictured here are two workers inside the Vought-Sikorsky Aircraft Corporation in Stratford.

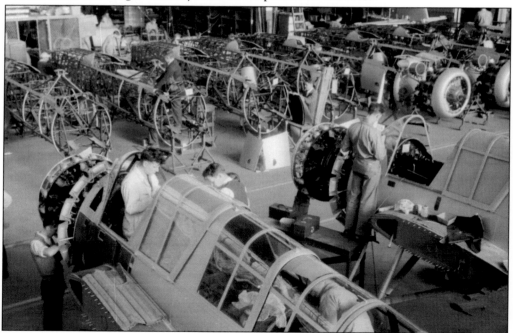

STRATFORD, DIVERSIFICATION, 1940. Sikorsky did not always favor propellers above its pilots. Here, factory workers inside the Vought-Sikorsky Aircraft Corporation in Stratford are working on airplane bodies. It was Sikorsky's fifth airplane, the S-5, that garnered him national recognition.

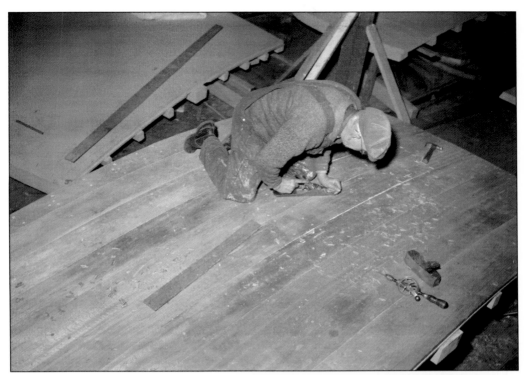

STAMFORD, FAIRFIELD COUNTY, 1942. Luders Marine Construction, founded in 1908 by Alfred E. Luders in Byram, Connecticut, moved to Harbor Drive in Stamford Harbor four years later. Here, the transom, or stern, of a wooden Navy sub chaser is planed smooth before being attached to the keel at an Eastern boatyard.

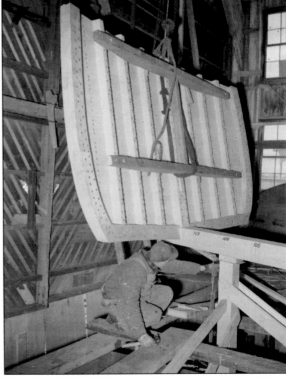

STAMFORD, WATERCRAFT PRODUCTION, 1942. Here, the transom has been swung into position for bolting to the end of the sturdy Luders oak keel. After World War II, Bill Luders was one of a committee of five boat designers who codified and regulated the International One Design class of yachts.

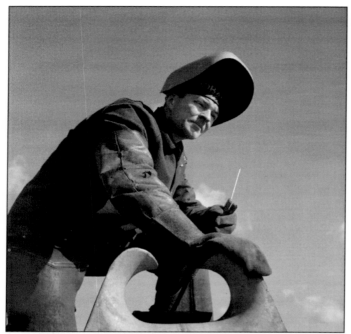

STAMFORD, BOATYARD WELDER, 1942. Here, an arc welder has just finished a job on one of the chocks of a chaser at Luders boatyard. For 60 years, until its demise in 1968, this yard built superb vessels for pleasure, such as the *Weatherly*, a notable defender of the America's Cup, and for war.

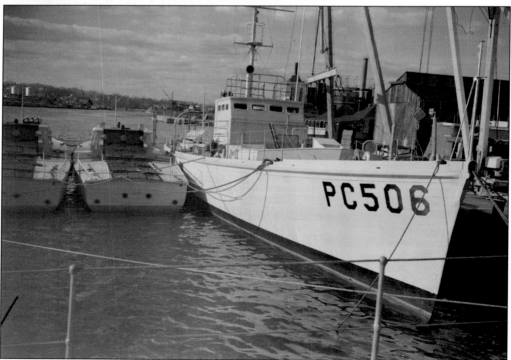

STAMFORD, SUBCHASERS, 1942. Target boats are moored alongside the newly commissioned submarine chaser from Luders Marine Construction. During World War II, the yard had as many as 1,200 employees and turned out more than 80 vessels—subchasers, minesweepers, patrol craft, harbor tugs, and tow-target boats.

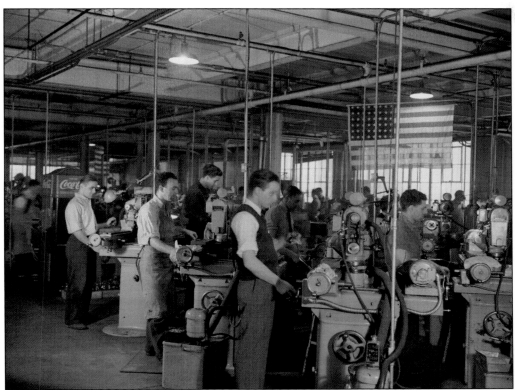

STAMFORD, MANUFACTURING CONVERSION, 1942. Inside this Schick plant, which typically produced shavers, employees turned out parts for machine tools in 1942. The conversion involved attaching new grinding wheels, minor changes to the head, and increasing the feed of the cutting solution. Such transformations preserved jobs and helped ensure victory.

STAMFORD, SPECIALTY SKILLS, 1942. War production was a tricky job but well suited to the skills of Schick workers.

TAFTVILLE, NEW LONDON COUNTY, 1940. A neighborhood of Norwich, Taftville was a small village in eastern Connecticut that made a name for itself in the cotton textile trade. The Taftville Cotton Mill began operation in 1871. It later became Ponemah Mills Inc. This is a view inside the cotton and rayon mill at Ponemah.

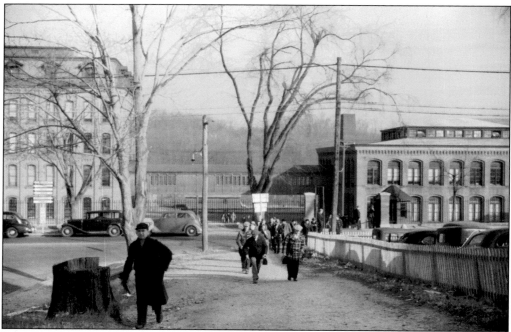

TAFTVILLE, ORGANIZED LABOR, 1940. This was the familiar view of a shift change at the mill. In its 100 years of operation, the mill, like so many other forms of manufacturing, experienced numerous struggles between workers and management.

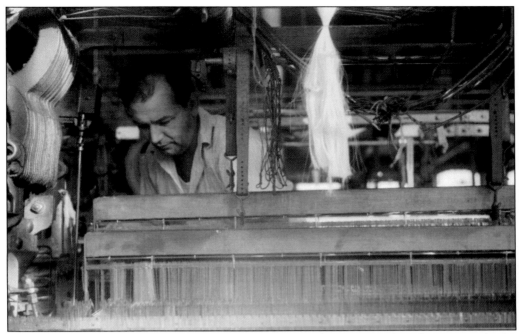

TAFTVILLE, TEXTILE PRODUCTION, 1940. Here is an exclusive view of production inside the Ponemah Mills in 1940. The textile factory was built on the Shetucket River, where a large dam could be constructed to provide power.

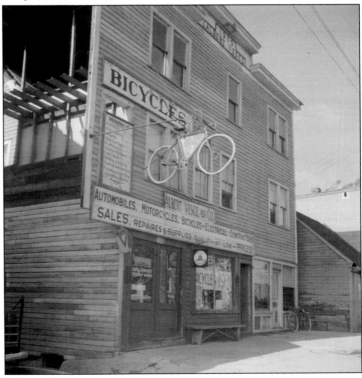

THOMPSONVILLE, HARTFORD COUNTY, 1940. Thompsonville was named after Orrin Thompson, who built a dam across Freshwater Brook in 1828 and opened the first carpet mill a year later. Carpet manufacturing remained in the town until 1971, when production shifted to the southern United States. Albert Vesce and Company, seen here in 1940, specialized in repairing anything with wheels, from bicycles to motorcycles.

THOMPSONVILLE, DAILY LIFE, 1940. Life in Thompsonville seemed simpler in September 1940. While sources can vary, today, just over half the state's residents consider themselves religious, or affiliated with a religion; most of them are Catholic.a

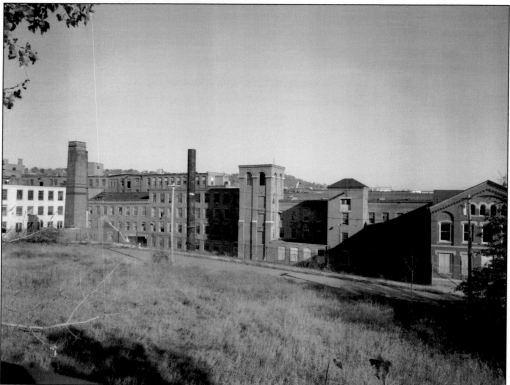

WATERBURY, NEW HAVEN COUNTY, C. 1969. Waterbury owes much of its identity to brass, which is an alloy of copper and zinc. For generations, the industry has forged Waterbury into "The Brass Capitol of the World." The Scovill Brass Works was established in Waterbury as Abel Porter and Company in 1802. Here is a view of the company's Mill Street buildings looking east.

WATERBURY, SCOVILL BRASS WORKS, C. 1969. Following World War II, the company's 12,000 employees manufactured a quarter of a million individual and distinct products. Looking east, this was the top of Rundbogenstil Tower, between Buildings 3 and 4, at 59 Mill Street in Waterbury.

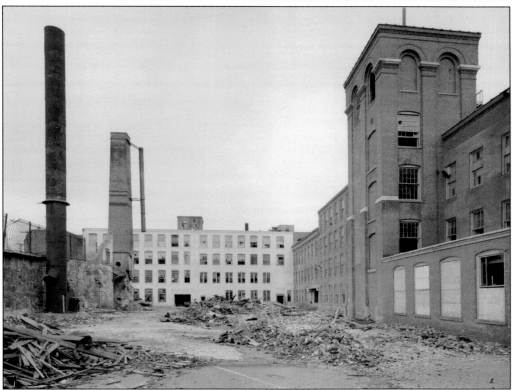

WATERBURY, INTEGRATED MANUFACTURING, C. 1969. The Waterbury plant was a completely integrated facility and was capable of performing all necessary manufacturing operations. Looking north, Rundbogenstil Tower is to the right, and the 1876 brick chimney is the shorter stack at left.

WATERBURY, SOUTHEAST VIEW, c. 1969. Scovill's presence in the community shaped Waterbury into the city it is today. The city witnessed a large growth in the number of Italian, Irish, and Russian immigrants during the 20th century. Looking southeast, John D.'s Pond (named for John D. Johnson, early land owner) is in the foreground, with the main power plant in the background.

WESTPORT, FAIRFIELD COUNTY, 1941. It was not the arrivals or departures that made places special during the war years, it was the memories in between. Here, in Westport, Connecticut, in 1941, a commuter is caught kissing his wife before catching a train for New York.

Four

THINGS

The accouterments of life were so rich and varied, so elaborated, that almost no place at all was left for life itself. Each and every accessory was so costly and beautiful that it had an existence above and beyond the purpose it was meant to serve—confusing the observer and absorbing attention.

—Thomas Mann

A thing can be an object that one need not, cannot, or does not wish to give a specific name to. It can be an inanimate object or an action, activity, event, thought, or utterance. A thing can also reflect an era or an event.

From bicycles and bowling to sledding and soda fountains, things have a way of instantly catapulting a person back in time. Songs, ticket stubs, and even matchbooks can evoke memories, if not preserve a moment. Saving things, which some Connecticut residents did, was a way of conserving the past.

Almost instantly, the memories return when things are thought about, for example: U-boats, *Casablanca*, rationing, war bonds, "Stormy Weather," and D-Day. In fact, things can elicit a wide range of emotions.

Things are sold in all shapes, sizes, and forms. One can hold them, throw them, sink them, and fold them. During World War II, the smallest things could often mean the most—things did not have to be big or expensive to be thought-provoking. If there was a psychological security—as some believe today—associated with someone's desire to save something, nobody appeared to care. After all, there was a war going on.

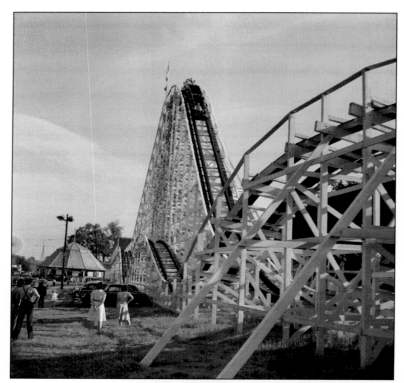

AMUSEMENT PARKS, LAKE COMPOUNCE, 1942. As residents needed a release from the tensions caused by the war, many turned to anything they could afford or enjoy. For those living around the Southington area, that might mean a bit of amusement park entertainment at Lake Compounce.

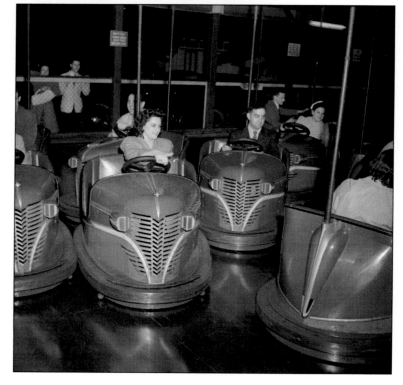

AMUSEMENT PARKS, BUMPER CARS, 1942. Pent up anxiety from the war? Well, the amusement park had the perfect solution: a small, electrically powered car with rubber bumpers all around, driven in an enclosure at an amusement park with the aim of bumping into other such cars.

APARTMENT LIFE, 1939. It was called living within one's means, be it inside a prefabricated dwelling or a rented apartment, such as this one in Meriden in 1939, just prior to the war. Neighbors were not only across the street or next door but also above or below. And one could often hear every word spoken by a neighbor.

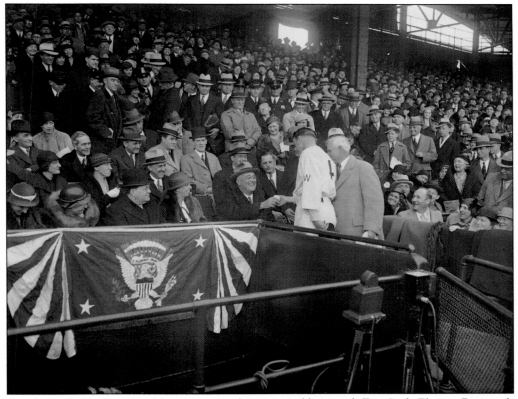

BASEBALL, 1932. Pres. Franklin D. Roosevelt is pictured here with First Lady Eleanor Roosevelt at a Washington baseball game. He understood after the Japanese attack on Pearl Harbor that the national pastime should not be suspended during World War II. Connecticut-born players who served included Pete Castiglione, Walt Dropo, Al Niemiec, Freddy Schmidt, Spec Shea, and a few others.

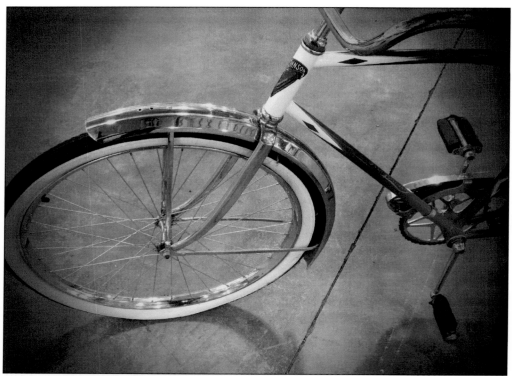

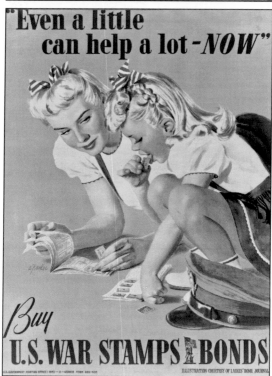

"Even a little can help a lot - *NOW*"

Buy

U.S. WAR STAMPS & BONDS

BICYCLES, 1939. Not everybody had a chance to own a bicycle as nice as this model produced by Iver Johnson's Arms and Cycle Works, out of Fitchburg, Massachusetts. The company, which also manufactured revolvers and single-barrel shotguns, shut down its bicycle shops in favor of addressing the dramatic need for guns leading up to World War II. (Courtesy of the New England Air Museum, Windsor Locks, Connecticut.)

BUY BONDS, 1942. The question became, should taxes be increased and force savings, or should a defense bond program be initiated? From large denominations to alternatives for those who could not yet afford one, war bonds—a name given after the Japanese attack on Pearl Harbor on December 7, 1941—became the answer. Posters supporting the drive, such as this one, were soon posted everywhere.

BUY BONDS, STAMP ALBUM, 1942. For those who found it difficult to buy an entire bond at once, 10¢ savings stamps could be purchased and collected in Treasury-approved stamp albums until the recipient had accumulated enough for a bond purchase. The front of the 10¢ stamp album featured a patriotic design. (Author's collection.)

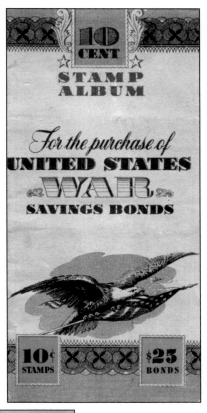

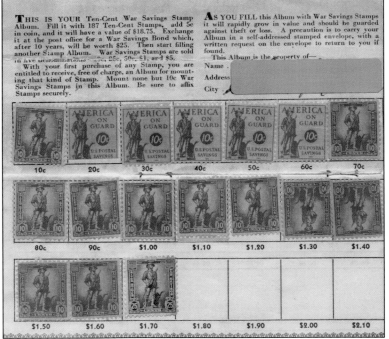

THIS IS YOUR Ten-Cent War Savings Stamp Album. Fill it with 187 Ten-Cent Stamps, add 5c in coin, and it will have a value of $18.75. Exchange it at the post office for a War Savings Bond which, after 10 years, will be worth $25. Then start filling another Stamp Album. War Savings Stamps are sold in five denominations—10c, 25c, 50c, $1, and $5.

With your first purchase of any Stamp, you are entitled to receive, free of charge, an Album for mounting that kind of Stamp. Mount none but 10c War Savings Stamps in this Album. Be sure to affix Stamps securely.

AS YOU FILL this Album with War Savings Stamps it will rapidly grow in value and should be guarded against theft or loss. A precaution is to carry your Album in a self-addressed stamped envelope, with a written request on the envelope to return to you if found.

This Album is the property of—

Name .

Address

City .

BUY BONDS, SAVING STAMPS, 1942. The inside of the 10¢ stamp album pictured here explained the function of the US war savings stamps. (Author's collection.)

BOWLING, BANTAM, 1942. Here, in the basement of the Bantam town firehouse, was a bowling alley, revenue from which helped to support the town's volunteer fire companies. Each night was allotted to a specific group, and there were several hot rivalries. Mrs. Winfield Peterson, whose husband was a foreman at the Warren McArthur experimental shop, is among the women pictured here in 1942.

BOWLING OR BOCCE, 1942. A popular alternative to bowling was bocce, also spelled boccie or bocci, which is an Italian game similar to lawn bowling but played on a shorter, narrower green. Pictured here in May 1942 on what appears to be a homemade court is a group of men from Southington.

CANDY, 1938. Before the war, Connecticut residents had plenty of candy: Snickers Bar (1930), Tootsie Roll Pops (1931), Red Hots (1932), 3 Musketeers (1932), 5th Avenue Candy Bar (1936), Sky Bar (1938), and much more. Hopefully, some readers will see their favorite in this image. How about a Jolly Jack, Milky Way, or KokoNutRoll?

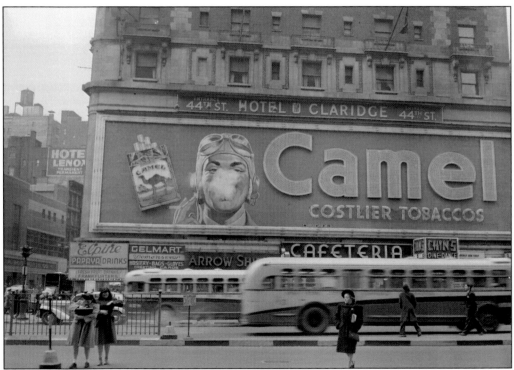

CIGARETTES, 1943. "Smoke 'em if you got 'em" was the order of many a company commander during World War II. While the more popular brands—Camels, Chesterfields, Kools, and Pall Malls—made it overseas, those stuck home did all they could to find a pack of Rameses or Pacayunes. How many people recall taking the train into the city and witnessing firsthand this famous 1943 Camel "smoking" cigarette advertisement at Times Square?

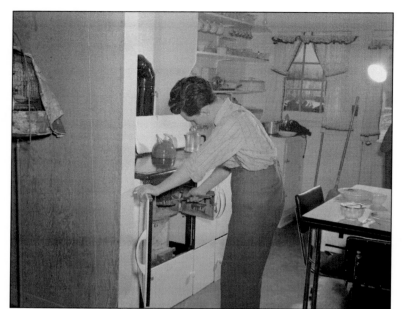

"ROLL YOUR OWN" CIGARETTES, 1942. This heating unit was in the kitchen of Fred Heath's four-room apartment in the new federally financed homes for 80 families just a few minutes from the Warren McArthur factory in Bantam. That cigarette Heath holds was not factory-made, by the way—he liked to roll his own.

CIRCUS FIRE, 1944. Life at home meant trying to escape the horrors of war, so many turned to outlets such as the Ringling Bros. & Barnum and Bailey Circus. On July 6, 1944, a very warm and sunny afternoon, thousands found their way to Barbour Street in Hartford for a bit of fun under the big top. Less than 20 minutes into the show, an uncontrollable fire broke out. The screams were chilling as men, women, and children jumped for their lives from the bleachers. Over 160 spectators never made it home that day, and nearly 500 suffered injuries. (Author's collection.)

Circus Fire, Memorial Station, 1944. Flames and smoke filled the canvas enclosure, making exits nearly impossible to find. In less than 15 minutes, what once stood as a testament to people's ability to displace themselves from everyday challenges had been burned to the ground. Stations at the memorial provide a timeline of the tragedy while reminding visitors of the horror faced by attendees. (Author's collection.)

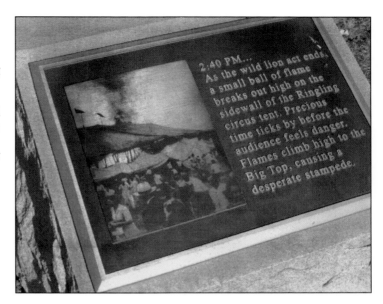

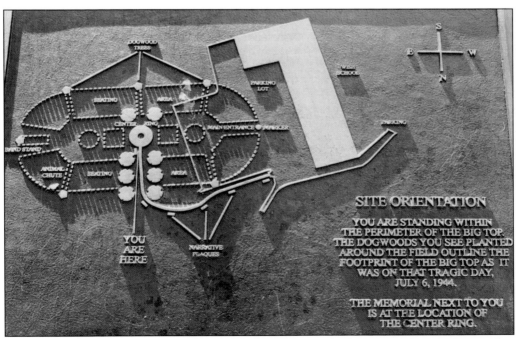

Circus Fire, Memorial Site Orientation, 1944. A site orientation plaque places visitors within the perimeter of "The Big Top," at the Hartford Circus Fire Memorial. (Author's collection.)

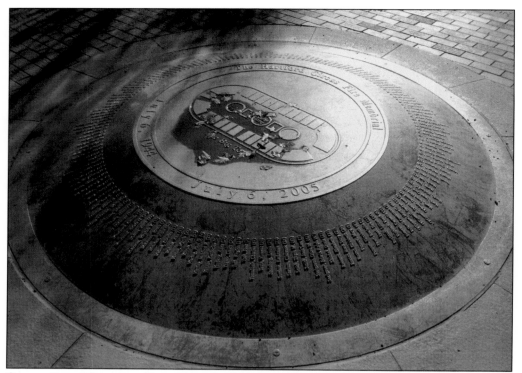

CIRCUS FIRE, MEMORIAL CENTERPIECE, 1944. It is difficult to imagine how hard it must have been to receive the news overseas that a loved one had perished at a circus, of all things. The Hartford Circus Fire Memorial, dedicated on July 6, 2005, stands as a lasting memorial to this tragedy. The major element of the shrine is its centerpiece. (Author's collection.)

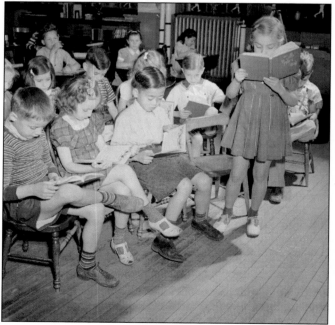

CLASSROOM INSTRUCTION, READING, 1942. The dynamics involved with a wartime education are complicated. With a majority of the male population overseas, family responsibilities fell to others. Women—who, by the way, now represented a sizable percent of the workforce—assumed virtually all roles. And to little surprise, they handled it with utmost proficiency both at home and in classrooms, such as this one in Southington in 1942.

CLASSROOM INSTRUCTION, TEACHING, 1942. Aware of the valuable contribution they were making to the war effort, Connecticut teachers performed admirably. They never balked at the challenging role of being an educator or even substituting, albeit temporarily, for the role of a parent.

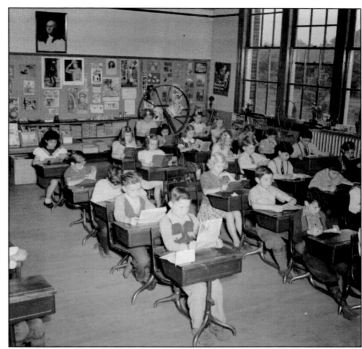

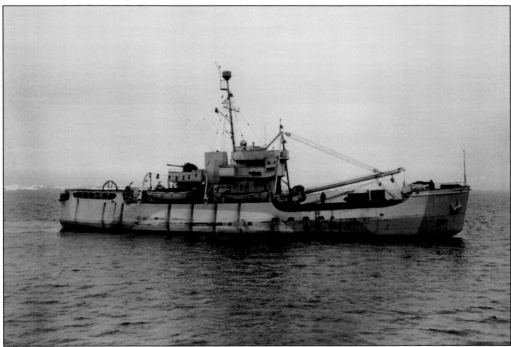

COAST GUARD, C. 1969. The *Evergreen*, pictured here in New London, was built to serve as a 180-foot US Coast Guard cutter. The federal government purchased 39 of these vessels, built in three sub-classes from 1942 to 1944. These vessels have significantly contributed to safe navigation on inland and international waters in times of peace and war.

DINING OUT, 1943. Food in restaurants was not rationed; however, many establishments instituted practices like one roll per customer. So, what about cost? A fresh crabflake salad at the Yale Barn Restaurant in East Canaan would run 75¢, which was still a bargain considering the Hotel Pennsylvania in New York City charged $1.65. This wartime menu shows what city prices were like. (Author's collection.)

ELECTRIC APPLIANCES, 1944. During World War II, time was of the essence, so every minute became valuable, especially in the kitchen. Electric blenders, toasters, and waffle makers became a necessity even if viewed by some as luxury items. (Courtesy of the Connecticut Historical Society.)

ENGINES, 1944. The Wasp Junior, introduced by Pratt & Whitney in 1930, was a complement to their lucrative line of aircraft engines and was one of the most successful reciprocating engines ever built. The 450-horsepower R-985 engine seen here was manufactured in 1944 and became so popular that it could eventually be found in over 60 types of aircraft. (Courtesy of the New England Air Museum, Windsor Locks, Connecticut.)

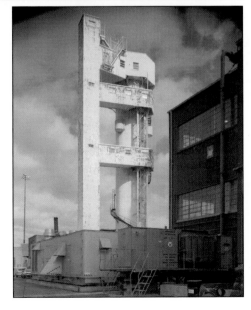

ESCAPE TRAINING TANK, C. 1969. From 1930 to 1994, the Escape Training Tank, located at Albacore and Darter Roads, was the most recognizable structure on the Naval Submarine Base New London. Standing 119 feet tall, generations of submariners learned the art of survival thanks to the structure and its gifted instructors. This was the impressive exterior view looking northeast at the tower.

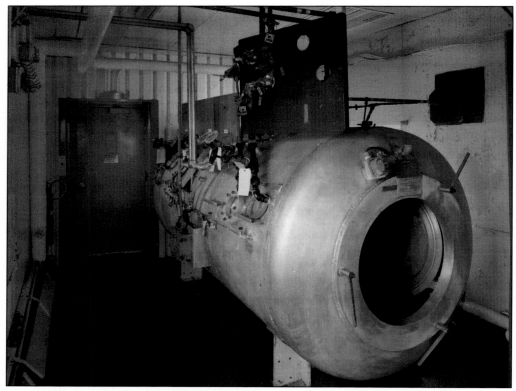

ESCAPE TRAINING TANK, INTERIOR VIEW, C. 1969. This is a view of the two-lock recompression or decompression chamber. This unit was a pressure vessel used in surface-supplied diving to allow the swimmers to complete their decompression stops at the end of a dive on the surface rather than underwater.

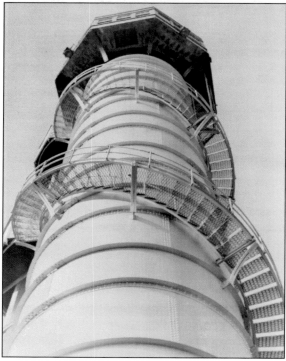

ESCAPE TRAINING TANK, EXTERIOR VIEW, C. 1969. This is an exterior view looking up at the east side of the tower. The structure contained locks or compartments, modeled on those in actual submarines, at the 18-, 50- and 110-foot levels, through which students from the US Naval Submarine School entered the tank and ascended under close supervision from instructors.

FILLING STATIONS, ATTENDANTS, 1942.
They were called filling or service stations, and an attendant tended to the needs of the automobile, from gasoline to checking the oil level. Granted, automobiles seemed to require much more attention in 1942 than they do today, but many will argue that the additional service was worth the cost.

FILLING STATIONS, ROAD MAPS, 1942. A service station was also where customers could buy a road map to navigate Connecticut or New England. They were a bit cumbersome at times, and a person could never fold them back to their initial state, but at least they were not lost.

FIRE DEPARTMENT, 1942. Southington's fire department, another example of tireless dedication, was an organization of 100 trained volunteers who battled flames without pay.

FOOTLOCKER/LUGGAGE/TRUNKS, 1941. It was always hard to believe a GI could manage to squeeze just about everything important, minus his girl of course, into a trunk or footlocker, but somehow they managed. The popular phrase "Kilroy Was Here!" and the distinctive accompanying doodle became associated with GIs in the 1940s. It could be found just about everywhere. (Courtesy of the Connecticut Historical Society.)

GOLD STAR/SERVICE STAR MOTHERS, 1936. A mere five years prior to the United States declaring war, these Gold Star mothers, including some from the state of Connecticut, gathered on September 27, 1936, at Arlington National Cemetery. By World War II, the term Gold Star had come to refer to the loss of a family member in military service. For example, the mother of a person who died in service was referred to as a "Gold Star mother," and the wife of an active service member was referred to as a "Blue Star wife."

GOLD STAR/SERVICE STAR MOTHERS, SOUTHINGTON, 1942. Daisy Morse, of Southington, had two sons fighting in the war—Pvt. Alfred Morse and LeRoy S. Morse—and displayed two service stars in her window. People in the state of Connecticut cherish the sacrifice given by area families and all Americans in the pursuit of freedom.

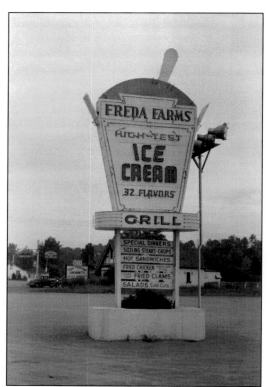

ICE CREAM STAND, FREDA FARMS, 1939. Everybody had their favorite ice cream stand during the war years, and for those residents living in Berlin, that often meant Freda Farms. With 32 flavors of ice cream, it was not a simple choice.

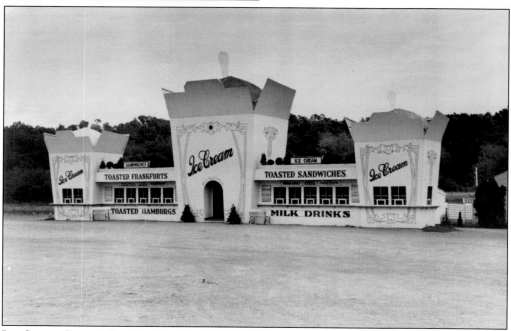

ICE CREAM STAND, ARCHITECTURE, 1939. How is this for an ice cream stand? Best of all, it was located on the Berlin Turnpike, or the strip between Hartford and Meriden, a 15-mile link on the main route between New York City and northern New England.

JEEP, INTERIOR VIEW, 1942. Pictured is the inside of the most universally recognized military vehicle used during World War II—the Jeep. It saw service in nearly every theater. Both the Ford Motor Company (Model GPW) and Willys-Overland (Model MB) produced Jeeps. The former was actually $133.85 more expensive per unit than the latter. (Courtesy of the New England Air Museum, Windsor Locks, Connecticut.)

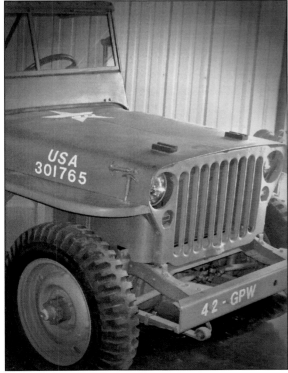

JEEP, EXTERIOR VIEW, 1942. Every branch of the US military used the Jeep. The GIs were quick to note that Ford marked every component of their vehicle with an "F." (Courtesy of the New England Air Museum, Windsor Locks, Connecticut.)

JUKEBOX, 1949. Like magic, one inserted a coin into a machine called a jukebox, and it automatically played a song. Popular recordings, such as "Chattanooga Choo Choo," "Stardust," and "Boogie Woogie Bugle Boy," were played often, which thrilled owners and thus stayed longer as selections inside the stand-alone machine. (Author's collection.)

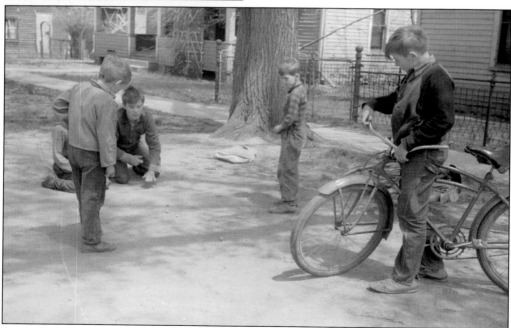

KID'S PLAY, MARBLES, 1940. Children played inside and outside, but the latter seemed far more prevalent. The outdoors was always more conducive to energy levels, or so it seemed. Boys always seemed to be playing marbles, as seen here. Stickball, an informal game resembling baseball that is played with a stick and a ball (usually rubber), was almost always an alternative.

KID'S PLAY, RING-AROUND-THE-ROSY, 1941. For the girls, fun was playing ring-around-the-rosy, a singing game where the players hold hands and dance in a circle, falling down at the end of the song. There were also skating rinks and roller skates and other forms of recreation.

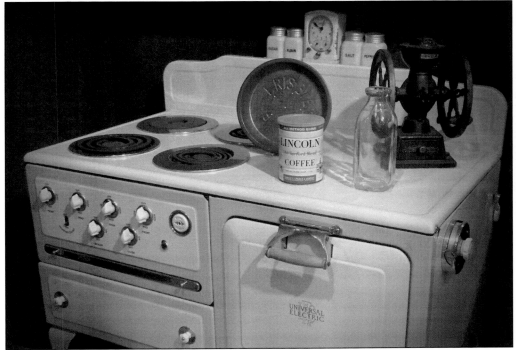

KITCHEN, C. 1940. The perfect addition to any modern kitchen was this Landers, Frary & Clark electric stove. The company, founded in 1853 in New Britain, was enormously successful and finally sold its Universal brand to General Electric in 1965. (Courtesy of the Connecticut Historical Society.)

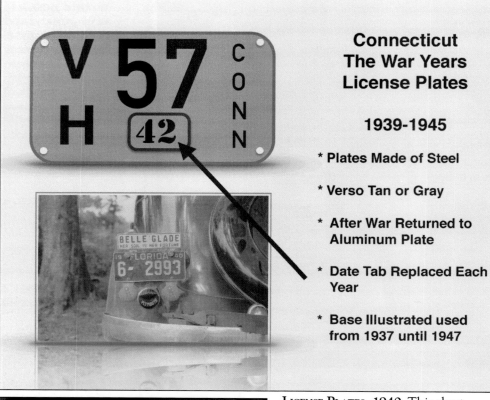

Connecticut
The War Years
License Plates

1939-1945

* Plates Made of Steel

* Verso Tan or Gray

* After War Returned to Aluminum Plate

* Date Tab Replaced Each Year

* Base Illustrated used from 1937 until 1947

LICENSE PLATES, 1940. This chart illustrates the design and function of a Connecticut black and silver license plate used on passenger vehicles during the war years. An innovation at the time was the state's use of a permanent base plate with renewals issued as tabs. The photograph, a 1940 Florida plate, can be used for comparison. (LC-DIG-fsa-8a06842; graphic, author's collection.)

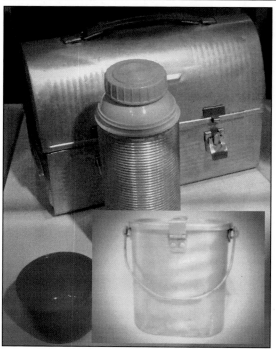

LUNCH BOX/LUNCH PAIL, 1941. President Truman had a lunch box or lunch pail, as did nearly every working American. Later, the Thermos (1904), a vacuum flask adapted to enable hot or cold beverages to remain at optimal temperature until lunchtime, became a common component. (Courtesy of the Connecticut Historical Society.)

MAGAZINE STANDS/ NEWSSTANDS, 1939. A trip to the corner grocery store or area newsstand, like this one in Windsor Locks, was how people got the majority of news during World War II. There, one could find newspapers such as the *Hartford Courant* or a robust selection of magazines, including *Colliers, Daring Detective, Liberty, Life, Look, Master Detective, Modern Romances, Photoplay, Picture Play, Real Detective, Romantic Story, The Saturday Evening Post, True, True Confessions, True Detective,* and *True Romances.*

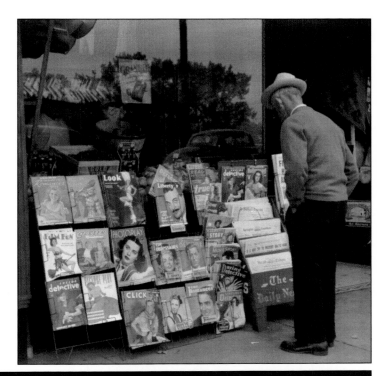

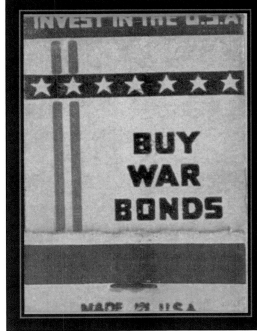

MATCHES, C. 1943. The exterior of a matchbook cover was usually imprinted with a producer's logo, often with artistic decorations. It served as an inexpensive advertising/promotional medium and was sold or given away. This cover had "Buy War Bonds" on the front, and "Keep 'Em Flying" on the back, Later, the Zippo lighter came along and changed everything. (Author's collection.)

MATCHES/LIGHTERS, PROMOTION, C. 1943. Pictured are more vintage matchbook covers. A testament to Connecticut quality is that some of these places are still in business. Patricia's is located on Whalley Avenue and still serving great food. The elegant Hartford Golf Club, established in 1896, is located at 134 Norwood Road in West Hartford, and the beautiful Yankee Pedlar Inn is located at 93 Main Street in Torrington. (Author's collection.)

MERRITT PARKWAY, 1941. The goal of the Merritt Parkway was to reduce highway congestion on Route 1 along the Connecticut shoreline. Built primarily under the watchful eye of Connecticut state highway commissioner John A. MacDonald (who served from 1923 to 1938), "The Merritt" was completed in 1940 and ran 37.5 miles, from the New York border to Milford, Connecticut.

MERRITT PARKWAY, MOREHOUSE HIGHWAY BRIDGE, 1941. Not only did the parkway enhance the highway experience by reducing traffic lights, but its vistas, consisting of native trees and shrubs, provided extraordinary scenery complemented by ornamental Art Deco– and Art Moderne–style bridges. This was the Morehouse Highway Bridge as it appeared in 1941, spanning Merritt Parkway at Fairfield.

MERRITT PARKWAY, NORWALK RIVER BRIDGE, 1941. The Norwalk River Bridge, spanning the Norwalk River, has been noted for its concrete arches.

MEALS, HOLIDAYS, 1940. Here, a member of the Crouch family, from Ledyard, is examining his 1940 Thanksgiving dinner.

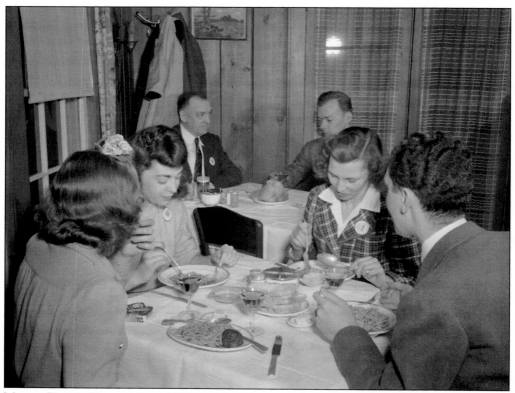

MEALS, TONY'S BANTAM INN, 1942. Spaghetti was a daily treat to many workers at the Warren McArthur plant, a furniture company that specialized in aluminum. Some workers ate both lunch and dinner at Tony's Bantam Inn. In the corner is Foreman Bundock, from the upholstery shop, and sitting with him is a young draftsman who just came to Bantam from a job in New York City, his home.

MILK, 1940. Even these Suffield, Connecticut, cows seem to understand that the state produced the best milk during World War II. Milkmen, who used either trucks or horse-drawn wagons for deliveries, carried fresh bottles of milk in handheld baskets right to the door and always picked up the empty ones. Over the years, the caps that topped the jars became collectable, such as those from the Torrington Creamery. Just the name on the cap brought back a flood of memories about the milk and ice cream plant on Riverside Avenue and, naturally, the Weigold family. At the creamery, it was often hard to decide what was better—the milk or the ice cream. The latter was likely a result of master ice cream maker Ed Dreger.

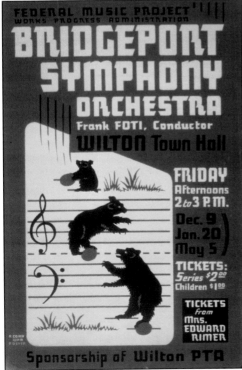

MUSIC, 1938. During the war, everyone had their favorite songs, such as "White Christmas," "Swinging on a Star," "Don't Fence Me In," "You'll Never Know," "Close to You," or "Sunday, Monday, or Always" or their favorite artist, be it Bing Crosby or Frank Sinatra. For classical music, residents often turned to local artists in the symphony orchestras. Advertised in this prewar Works Progress Administration poster is the Bridgeport Symphony Orchestra, conducted by Frank Foti.

MUSIC, "OL' BLUE EYES," 1942. Kept safely inside a Connecticut GI's wallet was this rare, unpublished image of Frank Sinatra during World War II. "Ol' Blue Eyes" could melt a heart faster than one could melt a stick of butter. (Author's collection.)

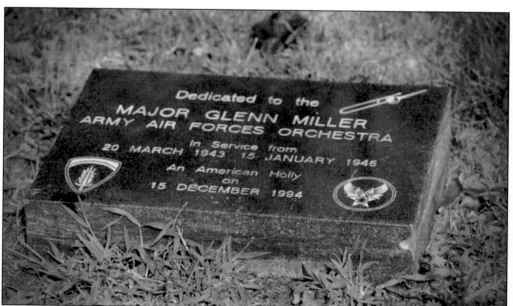

MUSIC, GLENN MILLER MEMORIAL, 1944. On December 15, 1944, while he was traveling to entertain US troops in France, Glenn Miller's aircraft disappeared in bad weather over the English Channel. At his daughter's request, this stone was placed in Memorial Section H, Number 464-A on Wilson Drive in Arlington National Cemetery in April 1992. (Author's collection.)

MUSIC, WOODY GUTHRIE, 1943. Woodrow Wilson "Woody" Guthrie, best known for his song "This Land Is Your Land," was more than an American singer-songwriter and musician. His musical legacy included hundreds of political, traditional, and children's songs, along with ballads and improvised works. He was also a member of the US Merchant Marines during World War II.

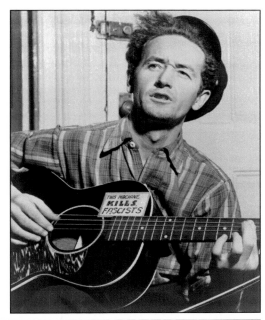

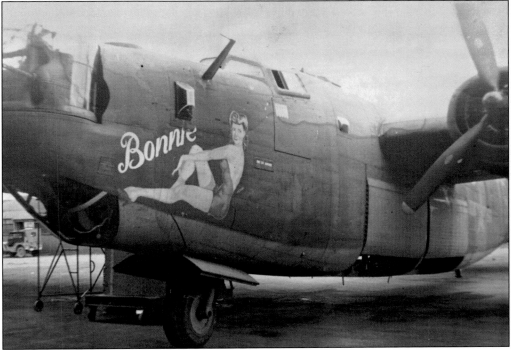

NOSE ART/PIN-UP, 1945. Folk art to some, and a good luck charm to others, nose art found a home during the war years on the front fuselage of many an aircraft. From "Honey Bunny" and "Juicy Lucy" to "Bonnie" and "Betty," a touch of home, or a soldier's imagination, was never far from the hand of an artist. Some became rather popular, such as Tony Starcer, a line mechanic for the 91st Bombardment Group (Heavy), VIII Bomber Command, 8th Army Air Force, based at Bassingbourn, United Kingdom, in 1942–1943.

Parade/Holidays, Colchester, 1940. As evidenced by these parade photographs, Armistice Day was a popular event. It was commemorated every year on November 11th to mark the armistice signed between the Allies of World War I and Germany at Compiègne, France. It took effect at 11:00—the "eleventh hour of the eleventh day of the eleventh month" of 1918. Here, the Colchester Community Band prepares for the parade.

Parade/Holidays, Veterans Day, 1940. The name of the Armistice Day holiday was later changed to honor veterans of all military conflicts. All Veterans Day, later shortened to Veterans Day, seemed far more appropriate. The citizens of Colchester agreed.

PHONES, 1945. Most of the telephones during World War II used a pulse dialing technology implemented through a rotary, or decadic, dialing system. The big wheel affixed to that black box was called a rotary dial. The digits were arranged in a circular layout so that a finger wheel could be rotated with one finger from the position of each digit to a fixed stop position, implemented by the finger stop, which was a mechanical barrier to prevent further rotation. Compared to today's technology, it seemed like an eternity to dial a simple number. (Courtesy of the Connecticut Historical Society.)

POCKET CHANGE, 1943. From steel cents to silver nickels, even pocket change was transformed during World War II. Washington quarters, Mercury dimes, and Walking Liberty half-dollars were struck in a 90 percent silver and 10 percent copper mix. (Author's collection.)

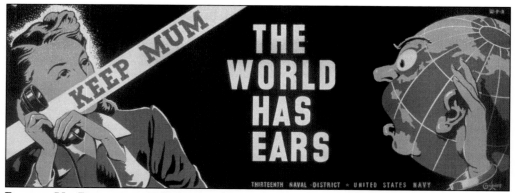

POSTERS, USE DISCRETION, 1941. It seemed everywhere people turned, there was a poster reminding them of the war effort. These mass-produced multicolor silkscreen posters encouraged viewers to avoid, assist, and preserve resources.

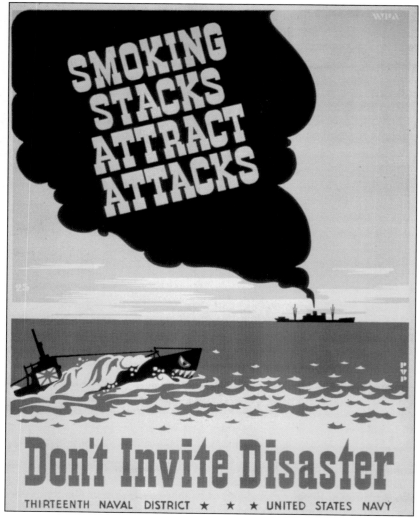

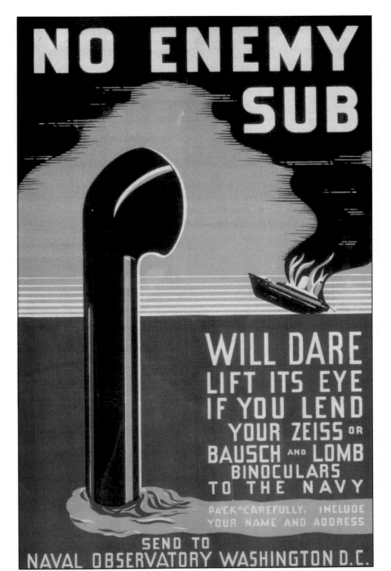

POSTERS, CONTRIBUTE RESOURCES, 1941. The goal during World War II was to assist the war effort on every front. If a poster could preserve a resource, then it was worth the paper it was printed on.

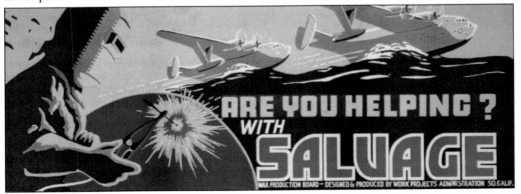

POSTAL SERVICE, MONTVILLE, 1940. Here, a group of youngsters plays outside the Montville, Connecticut, post office in November 1940. But there was nothing childish about the mail delivery during armed conflict, as many considered it no less a priority than food or ammunition.

POSTAL SERVICE, BROOKLYN, 1940. Before the term multitasking was ever invented, there were towns that could not support a stand-alone post office, so it was incorporated into the general store. Here, in Brooklyn, Connecticut, one could buy a pack of razors and mail a first class package thanks to proprietor Arthur E. Mott.

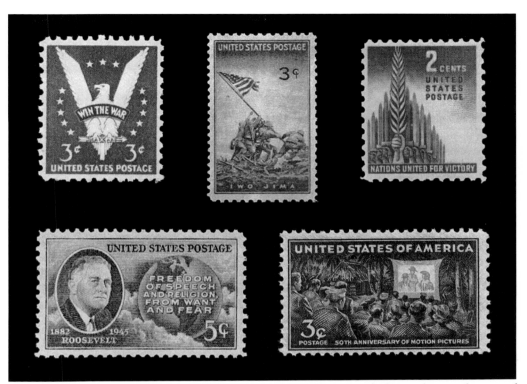

POSTAL SERVICE, POSTAGE STAMPS, C. 1945. Before a GI ever opened a letter, the significance of his service just might be found on the stamp affixed to it. The mission was clear: "Win the War." (Courtesy of the US Postal Service.)

PREFABRICATED HOUSING, 1941. Pictured here is defense housing under construction near the airport in Hartford. The site was constructed and managed by the Farm Security Administration.

PREFABRICATED HOUSING, EASY TO ASSEMBLE, 1941. Prefabricated homes, often referred to as prefab homes or simply prefabs, are unique dwellings aimed at satisfying the needs of particular workers. They are manufactured off-site in advance, usually in standard sections that can be easily shipped and assembled.

PREFABRICATED HOUSING, LENDING A HAND, 1941. The Sears catalog began offering mail-order kit homes between 1902 and 1910, so the idea of prefabricated housing was not new.

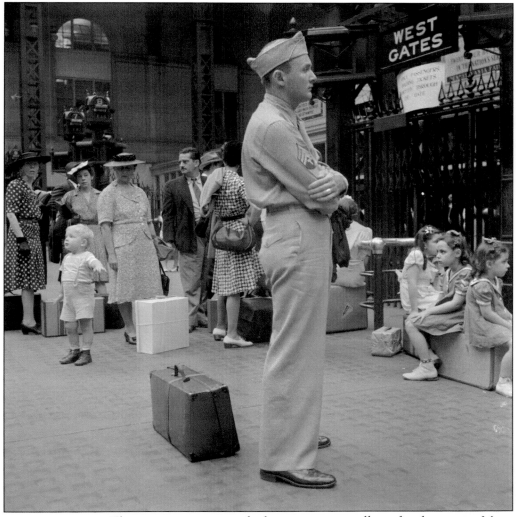

RAILROADS, 1942. The serviceman waiting for his train was an all too familiar scene. Many Connecticut soldiers made train connections at the Pennsylvania Railroad station in New York City. As had been done in the previous war, the president enacted the 1862 law and federalized the railroads.

RAILROADS, THE HEART OF THE COUNTRY, 1945. The US railroad system became the heart of the country during World War II. Both freight and passenger traffic (the latter witnessing a renaissance of sorts) moved thousands of tons of resources from coast to coast. And America did so with less track, heavier freight cars, and no new diesel locomotives. (Author's collection.)

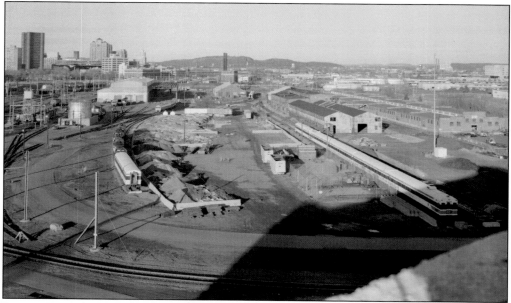

RAILROADS, NEW HAVEN, C. 1969. The buildings in the New Haven Rail Yard are associated with southern New England's most important rail carrier of the late 19th and early 20th centuries—the New York, New Haven & Hartford Railroad. In addition to a near monopoly on freight, the railroad operated one of the busiest passenger services in the country.

RAILROADS, TRANSPORTATION ARCHITECTURE, C. 1969. Noted American architect Henry Hobson Richardson, known for his public buildings, including several Boston & Albany Railroad depots, was hired by the Central Vermont in September 1885 to design a new rail station. New London Union Station, which still services the northeast corridor, was completed in 1887 and was the last and largest railroad station completed by the famed designer.

RAILROADS, STATION INTERIOR, C. 1969. This was the interior waiting room of the New London Union Station in New London. Just imagine if these walls could talk. There was a romantic uncertainty associated with train travel during World War II. Perhaps the poet Edna St. Vincent Millay summed it up best with these words: "My heart is warm with the friends I make, And better friends I'll not be knowing, Yet there isn't a train I wouldn't take, No matter where it's going."

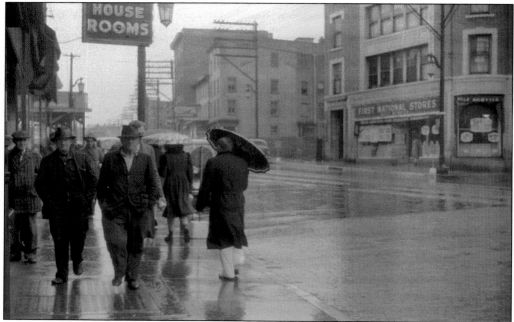

RAINY DAYS, NORWICH, NOVEMBER 1940. It is time to take Connecticut residents back to a rainy day in November 1940. In this view of a Main Street intersection in Norwich, some will recognize places like the self-service First National Stores, the Wauregan Hotel, and the F.W. Woolworth Co. 5 and 10 Cent Store.

RAINY DAYS, UNDER THE UMBRELLA, NOVEMBER 1940. The First National Stores drew shoppers inside through posters and promotions. The store was running a campaign and giving away a Firestone radio.

RAINY DAYS, GRABBING LUNCH, NOVEMBER 1940. For anyone who wanted to get out of the rain, an elegant meal could be found at the Wauregan Hotel, while a cost-effective alternative on Main Street was always a soda and sandwich at the Candy Mart counter. It was located next to the Norwich Savings Society. And do not forget Liggett's, at Shannon Corner, on the ground floor of the Shannon Building.

RAINY DAYS, CITY STREETS, NOVEMBER 1940. Norwich picks up about five inches of rain—at least it is not snow—every November, so residents and visitors alike are advised to have their umbrellas with them, as it will most likely rain.

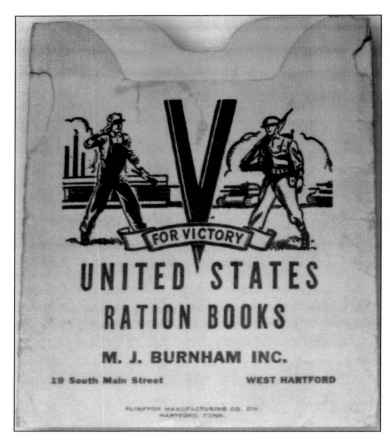

RATINGING, SPRING 1942. Rationing was the art of fixing the amount of a commodity allowed to each person during wartime and was a way for the federal government to control supply and demand. In the spring of 1942, the Food Rationing Program was set into motion. Coupons were distributed based on family size, and the coupon book allowed the holder to buy a specified amount if it was available. Surprising few, a black market soon developed for certain foods. Here, the "V for Victory" was printed on a ration book envelope. (Courtesy of the Connecticut Historical Society.)

RATIONING, DECISION MAKING, 1942. In addition to food, rationing encompassed clothing, shoes, coffee, gasoline, tires, and fuel oil. Some foods, like eggs and milk, were rationed by allocating supplies to shops in proportion to the number of customers registered there. People were permitted one egg per fortnight, but this, like other foods, was not guaranteed. This partially-used ration book is a reminder of the sacrifices made during World War II. (Author's collection.)

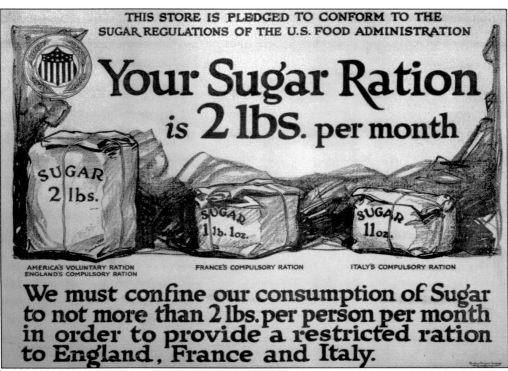

THIS STORE IS PLEDGED TO CONFORM TO THE
SUGAR REGULATIONS OF THE U.S. FOOD ADMINISTRATION

Your Sugar Ration
is **2 lbs. per month**

SUGAR
2 lbs.

SUGAR
1 lb. 1oz.

SUGAR
11 oz.

AMERICA'S VOLUNTARY RATION
ENGLAND'S COMPULSORY RATION

FRANCE'S COMPULSORY RATION

ITALY'S COMPULSORY RATION

**We must confine our consumption of Sugar
to not more than 2 lbs. per person per month
in order to provide a restricted ration
to England, France and Italy.**

RATIONING, NOT SO UNCOMMON, 1917. Rations varied considerably; the cheese ration, for example, varied from one ounce per person per week to eight ounces. Rationing was not a new concept, as pictured in this poster from World War I.

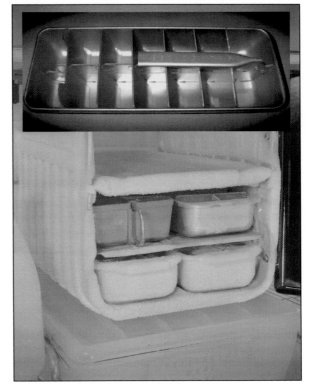

REFRIGERATION, APPLIANCES, 1942. Refrigerators gradually replaced the Connecticut icemen and the iceboxes they serviced. The Westinghouse version pictured here was still struggling, as were its users, with just how to handle the defrost cycle. Few liked the metal ice cube trays, with or without the handles. (LC-DIG-fsa-8e10732; insert Author's collection.)

SEWING, PATTERNS, c. 1945. The art of sewing was enhanced by the advent of pattern establishments, such as the McCall Pattern Company, Vogue Pattern Service, or Simplicity Pattern Company. As it was one of the fastest-growing firms, most are familiar with the easy-to-use and lower-price patterns of the Simplicity Pattern Company. Simplicity's unprinted patterns ended in 1946, and their patterns were all printed thereafter. (Author's collection.)

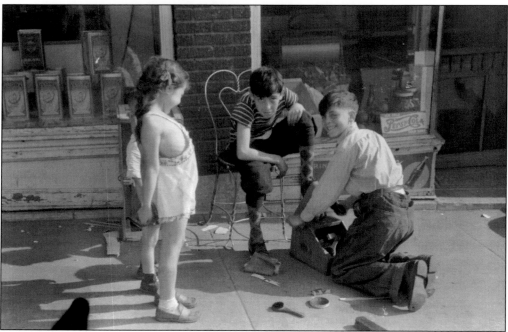

SHOESHINE, 1941. "Hey Mister, how about a shine?" A person employed to polish boots and shoes was called a bootblack or shoeshiner. Pictured here in Hartford are children performing or viewing the art of the shine after they realized they were being captured on film.

Sledding, 1940. Winter meant sledding and digging out the old Flexible Flyer, for those who were lucky enough to own one. The rider would lie down on their stomach face first, which was easy as long as the person was not too tall. The sled was then steered with the use of a wooden piece that resembled a crossbow, and the rope was attached to the steering board. The rope was also used to pull the sled up the hill. Riders could also sit on the sled and use their feet, or the rope, to steer. In November 1940, gifted government photographer Jack Delano captured these two images in Jewett City.

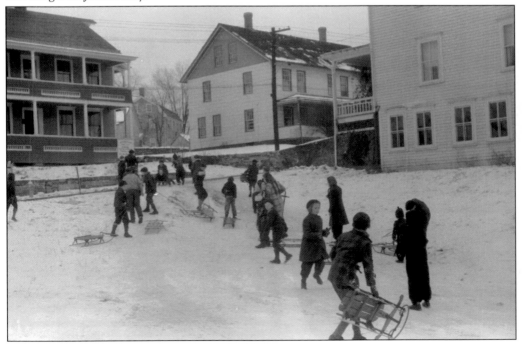

SNEAKERS, 1949. These shoes were designed for physical activity and went by all sorts of names: sneakers, athletic shoes, hi-tops, lo-tops, takkies, tennis shoes, runners, trainers, or even by the name of their manufacturer. During World War II, most sneaker material was earmarked for other use, but by the end of the decade, everything would change with the introduction of PRO-Keds. (Courtesy of the Connecticut Historical Society/the Naugatuck Historical Society.)

SODA FOUNTAIN, 1942. For those living in Southington, refreshment might mean Dimitrios Giorgio's soda fountain, pictured here. From pharmacies, ice cream parlors, and candy stores to dime stores, department stores, milk bars, and train stations, soda fountains could be found almost anywhere and flourished during World War II, not only for their light lunches but also for the social element they provided.

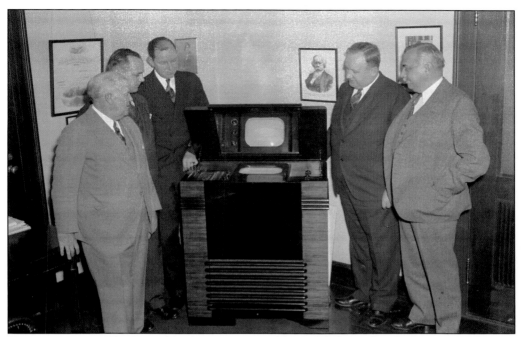

TELEVISION, 1939. The first public demonstration of the new lightweight television equipment was given on December 1, 1939, before members of the Federal Communications Commission. From left to right are commissioners Frederick I. Thompson and T.A.M. Craven, chairman James L. Fly, and commissioners Thad H. Brown and Norman S. Case. Television sets would not become commonplace until after World War II.

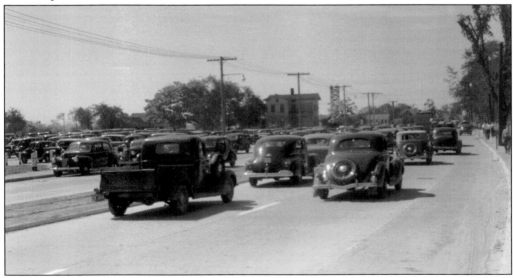

TRAFFIC, EAST HARTFORD, 1941. This is a view of the congestion created by vehicles during afternoon shift changes at the United Aircraft plant in East Hartford. United Aircraft ranked sixth among US corporations in the value of wartime production contracts, which certainly does not surprise those who worked endless hours at the local facility. United Aircraft entered the world of jet engines and helicopters via Pratt & Whitney and Sikorsky, respectively.

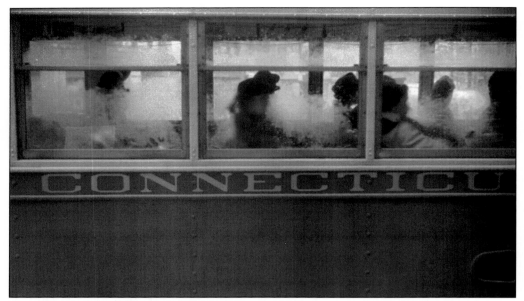

Transit, Norwich, 1940. This is an all too familiar image of commuters inside a Norwich bus on rainy day in Connecticut in 1940. The lack of proper ventilation made bus travel nearly intolerable.

USO, 1978. The United Service Organizations (USO) was a nonprofit organization that provided programs, services, and live entertainment to US service members and their families. The first entertainer called to mind by most GIs as being synonymous with the organization is Bob Hope. In 1997, the US Congress honored Hope by declaring him the "first and only honorary veteran of the US armed forces." This note, signed by USO entertainers Hope, Jack Pepper, and Frances Langford in North Africa in 1943, ended up in the hands of a Connecticut resident after being carried for years inside the wallet of a GI. (Author's collection.)

VICTORY GARDEN/MASON JARS, 1939.
Molded glass jars, known as Mason jars, Ball jars, or fruit jars, were found in every food pantry or root cellar during World War II. Both regular and wide-mouth jars came in a variety of volumes—cup, pint, quart, and half-gallon—to fit a canner's every need.

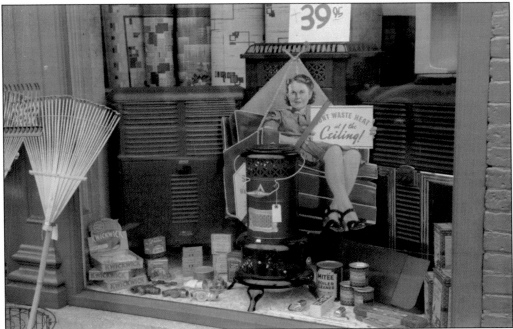

WINDOW DISPLAY/WINDOW SHOPPING, HARDWARE STORE, 1939. After the motion picture show on a Friday or Saturday evening in Windsor Locks, there was nothing like a stroll with one's date down the street to window shop. It was a way to escape reality and as much a part of the courting process as a goodnight kiss, or so it seemed. This was a hardware shop window, not always romantic, but practical.

WINDOW DISPLAY/WINDOW SHOPPING, SPORTING GOODS STORE, 1939. Is it hunting season yet? Does anyone recognize those Xpert shotgun cartridge boxes? A few Connecticut residents might. And if shoppers did not opt for those, there were always Western Super-X shotgun shells.

YOUTH DRUM CORPS, 1942. Members of the Southington Youth Drum Corps prepare for the 1942 Memorial Day parade. Perhaps this generation's sacrifice—as so many Connecticut residents thought, hoped, and prayed—would lead to a better life for each and every one of them.

Five

IN THEIR HONOR

Every gun that is made, every warship launched, every rocket fired signifies in the final sense, a theft from those who hunger and are not fed, those who are cold and are not clothed. This world in arms is not spending money alone. It is spending the sweat of its laborers, the genius of its scientists, the hopes of its children. This is not a way of life at all in any true sense. Under the clouds of war, it is humanity hanging on a cross of iron.

—Dwight D. Eisenhower

The value of a human life destroyed during any conflict is not weighed only by its potential but by the promise it liberates in the lives of others. And that promise can be fulfilled if it is understood. Like war, that burden falls on each and every person. Understanding that not everyone has the resources to travel to Arlington National Cemetery or the beaches of Normandy, France, is only part of the reason why so many Connecticut hamlets have monuments to military heroes. So take a minute while stopped at a sign in Bolton or at a traffic signal in Colchester to recognize these structures erected to commemorate Connecticut's heroes.

According to the War Department, in June 1946, "The State of Connecticut contained 1.27 percent of the population of the United States and possessions (excluding the Philippine Islands) in 1940 and contributed 1.46 percent of the total number who entered the Army. Of those Connecticut men and women who went to war, 3.04 percent failed to return. The figure represents 1.41 percent of the Army's total dead and missing." Here is a reminder of the casualties of World War II: During the war years, 1941–1945, there were 405,399 recorded deaths among US service members. That was about 0.3 percent of the population at the time, with an average of 297 deaths each day.

Each person who took his or her station at the factory, or a position at the front of the classroom, or even in the pulpit at local places of worship understood that they were emblematic of the Connecticut values that shaped citizen's lives and that one soul could make a difference. And, if lucky, one soul could save more than one soul, which might include that of a neighbor or a loved one.

Tabulation By Counties And Types Of Casualties

Abbreviations: KIA = killed in action, DOW = died of wounds, DOI = died of injuries, DNB = died non-battle (sickness, homicide, suicide, etc...), FOD = finding of death, M = missing; Only those persons who died in a line-of-duty status are included. List was superseded by a list which was considered final.

County	Casualties						
	KIA	DOW	DOI	DNB	FOD	M	Total
Fairfield	630	84	3	290	79	11	1097
Hartford	740	104	3	290	93	8	1238
Litchfield	141	29		56	5	1	232
Middlesex	73	10		44	8	1	136
New Haven	705	95	11	248	80	4	1143
New London	159	19	1	58	10	3	250
Tolland	40	8		15	3		66
Windham	88	15		39	4	1	147
State at Large	26	3		9			38
Totals	2602	367	18	1049	282	29	4347

Source: War Department, June 1946

TABULATION OF CASUALTIES, 1946. The War Department issued this World War II Honor List of Dead and Missing Army and Army Air Forces Personnel from Connecticut in June 1946. Other branches have their own summaries. For example, the Department of the Navy issued a State Summary of War Casualties from World War II for Navy, Marine Corps, and Coast Guard Personnel from Connecticut in 1946. This list confirms 353 deaths, as of February 1946, to add to the total.

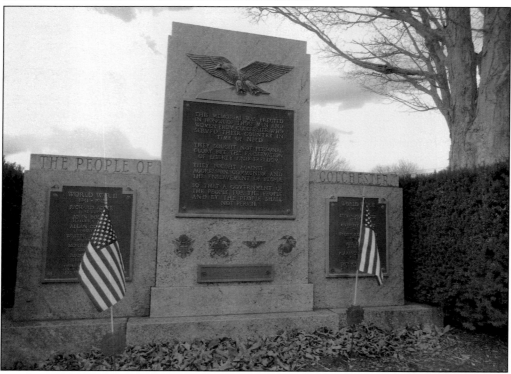

COLCHESTER, 1952. The gifted American essayist, lecturer, and poet Ralph Waldo Emerson quipped, "Cultivate the habit of being grateful for every good thing that comes to you, and to give thanks continuously. And because all things have contributed to your advancement, you should include all things in your gratitude." All across this state, in small towns like Colchester, are monuments and memorials dedicated to Connecticut's heroes. While patriotism has Memorial Day, Independence Day, and Veterans Day, gratitude asks only for today. (Author's collection.)

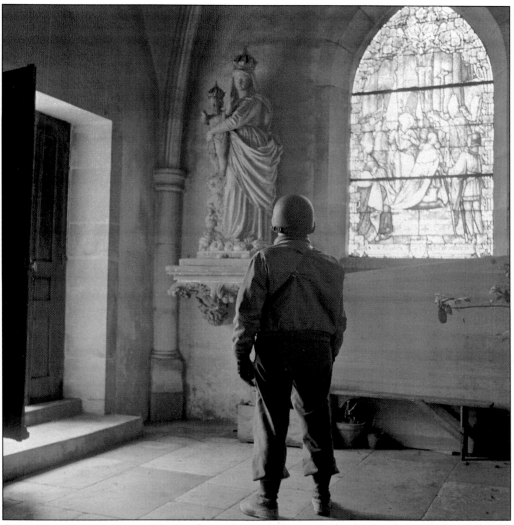

CONNECTICUT, 1941–1945. To paraphrase the Catholic Prayer for the Dead, "Lord, those who die still live in your presence, their lives change but do not end. I pray in hope for my Connecticut family, relatives and friends, and for all the dead known to you alone."

DISCOVER THOUSANDS OF LOCAL HISTORY BOOKS FEATURING MILLIONS OF VINTAGE IMAGES

Arcadia Publishing, the leading local history publisher in the United States, is committed to making history accessible and meaningful through publishing books that celebrate and preserve the heritage of America's people and places.

Find more books like this at
www.arcadiapublishing.com

Search for your hometown history, your old stomping grounds, and even your favorite sports team.